IMAGE
of America

WEEKI WACHEE SPRINGS

weeki wachee

AT U.S. 19 AND FLORIDA 50
WEEKI WACHEE, FLA. 33512

AREA CODE 904
PH: 596-2200 OR 596-2155

"SPRING OF LIVE MERMAIDS"

* WORLD'S GREATEST UNDERWATER SHOW
* SIDE PADDLE WHEEL ADVENTURE CRUISE
* COVERED WAGON NATURE RIDE
* PATIO RESTAURANT
* SOUVENIR SHOP
* HOLIDAY INN

Dear Applicant:

Thank you for your request for information regarding a career as a Weeki Wachee Mermaid.

Applicants must have no fear of the water, be photogenic, 18 to 25 years of age, and have a pleasing personality. To qualify, you must pass a physical by our company doctor and a water test here at Weeki Wachee. Also, you must have an examination by our eye, ear, nose and throat specialist in Tampa. You must come here at your own expense, as we cannot guarantee employment until after we have seen you in the water.

If you are accepted, you will be paid $80.00 a month and furnished living quarters in our trainee cottage and three meals a day in our Patio Restaurant on the grounds during your training period.

The day you qualify for our show, which usually takes six to eight weeks, you start at $104.00 a month and may continue to live on the grounds with one or two of the other girls @ $25.00 per month, which includes lights, heat, TV, air-conditioning...everything except linens and food. There are monthly salary increases and some of our Mermaids gross as much as $600.00 a month.

If you are interested in a full-time career, fill out the enclosed application and return it together with a picture of yourself, preferably in a swimsuit, to the undersigned.

Sincerely,

Mahon

Jack Mahon
Public Relations Director

JM/cl

An Original Response Letter to Mermaid Applicants. This letter became a treasured possession of many young women. Once a mermaid wannabe contacted Weeki Wachee and expressed her interest, she received this letter explaining what each party could expect. This particular letter was provided by Sandy Schimelfening, who now lives in Washington State.

On the Cover: Do You Believe in Magic? Are mermaids real? They are in Florida, and that may be the only place on Earth you can visit with them and have the time of your life in a magical world. Weeki Wachee, on Florida's peninsular Gulf Coast or Nature Coast, is the smallest city in America. The mermaid on our cover is one of hundreds who have passed through the tiny town and made magic for its visitors.

IMAGES
of America

WEEKI WACHEE SPRINGS

Maryan Pelland and Dan Pelland

ARCADIA

Copyright © 2006 by Maryan Pelland and Dan Pelland
ISBN 0-7385-4247-4

Published by Arcadia Publishing
Charleston SC, Chicago IL, Portsmouth NH, San Francisco CA

Printed in Great Britain

Library of Congress Catalog Card Number: 2005937955

For all general information contact Arcadia Publishing at:
Telephone 843-853-2070
Fax 843-853-0044
E-mail sales@arcadiapublishing.com
For customer service and orders:
Toll-Free 1-888-313-2665

Visit us on the Internet at www.arcadiapublishing.com

We dedicate this book to Newton Perry and every one of the hundreds of mermaids and mermen who have dipped their fins in the waters of Florida's magical Weeki Wachee Springs.

Contents

Acknowledgments	6
Preface	6
Introduction	7
1. The Early Years and the 1940s	9
2. The 1950s and the 1960s	33
3. The 1970s and the 1980s	77
4. The 1990s and Beyond	105
List of Mermaids	125

Acknowledgments

We are deeply grateful for the generous assistance of some mermaids and significant others. Many have kindly shared their photograph collections and given permission to use them in this book so that those images can be shared for generations to come. Some have spent precious time helping us understand the past and present of this wonderful place. Some stretched their minds to the limit to come up with names and facts from the past 60 years. If there are errors, they have been made out of innocent love and faulty remembrances. Thanks to Barbara Wynns, Mary Fletcher, Ed Darlington, Bonnie Georgiadis, John Athanason of Weeki Wachee, Mayor Robyn Anderson, Vicki Smith, Genie Young, the Former Mermaid Group, Dianne McDonald, Sandy Schimelfening, Abi Bell, Jill Roddis, the staff and residents of Weeki Wachee, and anyone else who so graciously worked with us.

Preface

Weeki Wachee Springs, with all their natural beauty, have been enhanced through the vision, effort, and dedication of founder Newt Perry. Nancy Tribble, Teresa "Sis" Meyers, and Eddie Edwards were among the early employees that set the bar of excellence. Ned Stevens, Mary Ann Ziegler, Geraldine Hatcher, Margaret and Bunny Eppley, Steve Stevens, Dot Fitzgerald, Martha Strickland, and Ed and Mary Darlington were among the original group of trainees. The most wholesome instruction from Mr. Perry inspired us to fly over the bar. Everything was new, exciting, and fun, and was kept that way by his low-key teachings. Bonnie Georgiadis and Genie Young invested years of superior service to the park, visitors, community, and Nature Coast of Florida. They were an important part. Since 1946, there have been over 300 mermaids that have had the incredible magical experience of being on the "I've Done It" list. Dawn Douglas headed a 50 year reunion in 1997, rounded up many previous mermaids, and presented the show *Mermaids of Yesteryear*—a well-received, outstanding underwater extravaganza with many performances. Experiencing a breathtaking, live show has no equal. Remember Weeki Wachee with us.

 A special tribute to the authors must be noted for the diligent effort put forth gathering the pictures and stories to make this book possible. Well done.

<div style="text-align: right;">

"Ed the Great" Darlington
Mary Darlington Fletcher
The first mermaid and merman of Weeki Wachee

</div>

INTRODUCTION

Weeki Wachee could be the smallest city in America. It has a mayor. It has a water park, a wonderful river and natural spring, a grocery store, a bank, a motel, and a couple of tiny businesses. Within its boundaries are fewer than half a dozen homes, no church, no corner bar, and no cemetery. It also has the only theme park in the world with live mermaids. Sierra City, California, claims to be the nation's smallest city, but issue can be taken with that. Sierra City, compared to Weeki Wachee, is over-crowded. Their population is 200 residents. Weeki Wachee's population, at last count, was fewer than a dozen.

In October 1947, Newt Perry, just out of the navy, created a roadside attraction where pretty girls would demonstrate perfectly normal activities like eating, drinking, and even typing—underwater. He embedded an 18-seat "theater" in the bank of a natural spring there, put a sign out on the road, hired some local girls, and Weeki Wachee Park was born. Early on, the girls sat around in swim gear until they heard a car drive by. Then up they jumped, running out to the road to wave down passersby and sell the show.

Once the one-square-mile city was simply part of rural Hernando County, but in 1966, someone had the bright idea of incorporating the area around the park as a city. Why? So Weeki Wachee would appear on maps and road signs—a slick way to draw more tourists. You will find the center of the place at about 28.515 north latitude and 82.573 west longitude, in the Eastern Time Zone; on the west coast of the Florida peninsula, to be exact. Weeki Wachee is about 35 miles north of Tampa.

In the second half of the 20th century, technology swept the world along at a dizzying pace. The moment we grasped and embraced an idea, it was whipped out from under us to be replaced by something new. If you look back on the journey from 1950 to 2000, the mind boggles, and you have to wonder how anyone coped with the changes. We traveled to the moon and beyond, endured the sexual revolution, survived the 1960s and 1970s, put pedal to metal on the information highway, and watched our planet shrink to a sort of global economy.

For a long time, rural Florida felt timeless and immune to the chaos, but the frantic haste and sometimes frightening storm of change would catch up. The young ladies of Weeki Wachee enjoyed their 15 minutes of fame. While working their chosen part-time jobs as high schoolers, they rubbed shoulders with Hollywood notables, big business moguls, and all manner of tourists, but kids who performed at the spring and adults who exploited the idea carried family values and ideals intact through the maze of notoriety and local glamour. Ask any mermaid, and she will tell you that each person involved brought something valuable to the mix. There was never one individual person or show, costume, or idea that defined the gem that grew out of a former navy frogman instructor's quirky idea.

As you experience this book, the text will remind you what was happening across Florida and the nation during each era. The magical nature of Weeki Wachee's story and pictures is a lovely contrast to the real world. We encourage you to imagine how people—perhaps your parents or grandparents—must have felt as quiet rural living was squeezed by passenger jets, space travel,

and finally cyberspace. By the time the last photograph was made, Floridians accustomed to contending with local issues were very aware of the outside world rushing down its highways and superhighways in droves. The past has a lot to teach us. We agree with Arcadia Publishing that we all have an obligation to preserve and share the story of how we got here.

We decided to compile this book because our children, our parents, and we ourselves treasured the unmatched quiet beauty of a little attraction in Spring Hill. We are not historians. This book is not intended to be a diligent chronology or a perfectly organized and complete history of Weeki Wachee. We regret any names that didn't find their way onto our pages. The mermaids and their cohorts are scattered all over the world, and some are gone. We simply paint a picture of what life looked and felt like from a mermaid's perspective. It's a fascinating story.

It has been a wonderful adventure, putting this book together. It reinforced the notion that the film camera is truly one of the most significant inventions of the last 200 years. A host of photographers captured the record of how neighbors past and present lived—you will witness bright successes and perhaps some sad but edifying failures along the way. A widely divergent group of people took up their Brownie cameras, Instamatics, 35 mm cameras, or Hollywood movie cameras and preserved the way things were. Perhaps you can do the same for the next generation.

This area played a key role in the history of Florida. Tourism fuels the economy here, and Old Florida roadside attractions like Weeki Wachee, Monkey Island, Cypress Gardens, and Dinosaurland were key players in developing that industry. It has been said that all of the world's events and each of her people are only removed from each other by a tiny degree of separation. The city of mermaids has left a golden bit of memory in the hearts of people from all over the world.

One

THE EARLY YEARS AND THE 1940s

The 20th century came on with a vengeance. American women came into their own and technology flourished. Goods could be shipped faster. Businesses, even in Old Florida, looked for quicker, more scientific ways to produce and deliver. Vladimir Zworykin built the iconoscope, giving rise to television cameras. America ramped up its love affair with movies, and Technicolor was knocking at the door. Ann Blyth, Esther Williams, and a bevy of starlets inspired young women to follow their dreams.

When Pearl Harbor was bombed, families shuddered as the day that would live in infamy played out in their living rooms on the Philco radio sets. Newspapers, newsreels, radio, war correspondents, and photographers brought the war home as the age of media exploded. Edwin S. Porter's astonishingly high-tech film, *The Great Train Robbery*, rocketed Hollywood into the future.

After the war, while Newt Perry was thinking up an underwater theater, other inventors were just as fanciful. The 1940s spawned the Slinky, Silly Putty, cake mix, the Frisbee, the jukebox, microwave ovens, peanut butter, and Tupperware. Americans witnessed the first helicopter flight, the first jet flight, and the first electron microscope. Dacron was invented and maybe even used in mermaid costumes.

That era brought the first electronic computer and the first A-bomb. Vitamin A was synthesized for the first time. Long-playing records replaced 78-rpm recordings, the transistor was invented, and falling right in line with all of that, science fiction became a media cash cow. Newt Perry picked a perfect time to think about fantastical fantasy. Cars put people on the highways en masse, which is what brought them to Florida, which is where a light bulb went on in Newt's head, some young people had the times of their lives, and the story begins.

Wekiwoochee Springs, Hernando Co., Fla.

ONE OF THE EARLIEST IMAGES OF THE RIVER AND SPRING, 1909. The card's title says "Wekiwoochee River"—it has also been called "Weekiwachee," "Wekiwachee," and a couple of other variations. This photograph is of Mr. Peck and Mr. Hall in their wooden john boat. According to notes on the card, one of them passed away shortly after this photograph was made. It is certain that he had a fine time floating down the river in his day. It's hard to imagine the proliferation of wildlife and fish they must have encountered long before the area was developed. At that time, not many miles north of the park, lumber companies had just finished cutting down a huge forest of giant cypress trees that will never come back; that land is scrub and marsh now.

THE BANKS OF THE WEEKI WACHEE RIVER, VIEW TOWARD THE SPRING, 1907. Reminiscent of the times of Native Americans and pirates, this serenely natural view of the spring is very likely the earliest existing photograph of that spot. It is well preserved, sepia colored, and slightly soft around the edges, but as clear as the day it was taken. The water must have been as pure as it could possibly be. There weren't any mermaids known then—at least not performing ones—but dolphins and manatees abounded, and alligators cruised the river all day long. According to *EcoFlorida* magazine, Florida is the only place in the world where you can see both alligators and crocodiles in the same place—at the Everglades, not very far from Weeki Wachee.

LITTLE CABIN IN THE WOODS OF FLORIDA, 1935. Built on Weeki Wachee River's shore, this idyllic cabin was the first structure on what was to become one of Florida's original roadside attractions. Tourism was becoming America's favorite sport. The scene of dozens of brawls between neighborhood ruffians and notorious for drinking parties, the house burned to the ground before World War II.

THIS IS HOW IT ALL BEGAN IN 1947. Newton Perry figured out how to breathe compressed air underwater through rubber hoses. He and his partner, Al Smith, hired girls to demonstrate common activities underwater. This is the original crew of mermaids—local high school girls. In the early days, the performers may have been called "Aquabelles," but they soon became mermaids.

AQUABELLES WERE THE FORERUNNERS OF MERMAIDS. Mary Dwight Rose and Dianne Wyatt McDonald were two of the original Aquabelles—they created the adagio pose. Organized in St. Petersburg and directed by George Symons, they performed synchronized swimming at prestigious hotels. Newt Perry invited them to swim on opening day in October 1947. They were featured on the first two postcards and performed at Weeki Wachee for two years. They swam with Ann Blyth. Dianne remembers the castle put in the water for the *Peabody* movie and says it was there for a year, but an overweight vacationer got wedged in the window, and it was removed. The belles were not paid and often held grueling schedules, like an eight-hour shoot for *Look* magazine. They had no equipment or tails and practiced on the shore.

SOMETIMES BEAUTY IS LESS THAN SKIN DEEP, 1950S. There is, of course, an abundance of beauty in the rivers and springs of Florida. Some might see beauty in an alligator half submerged and waiting for his prey, but dragging one this size out of your work place probably would not appeal much. The big fellow who wore this skin came out of the park long ago; the maintenance crew displays the trophy.

BEFORE RADIO AND TELEVISION, ADVERTISING WAS A CHALLENGE. Even today, Florida State Route 19 is a main route from Tallahassee to St. Petersburg. The coastal region is characterized by springs, rivers, and water features, and the road provides access to many of them. Before the mermaids, this sign pointed travelers to natural features of interest along the coastal road. The "fish bowl" was the spring at Weeki Wachee.

WHERE IN THE WORLD CAN YOU MEET MERMAIDS? c. 1950. All tasks were done on site, by hand, as this unique idea took shape. This fellow is lettering a billboard. It is a far cry from today's sophisticated public-relations materials but served its purpose in days gone by and drew the crowds needed to get the idea off the ground.

MUSIC TO THE EYES. "Adagio" is a ballet term referring to skillful lifting and balancing. This fluid pose quickly became a signature of the mermaids. The pose was adapted as statues designed for the entrance by St. Petersburg sculptor Gene Eley. The two sirens pictured, from a 1947 photograph, are Sis Meyers (top) and Nancy Tribble, who were still performing near the beginning of the 21st century.

START AT THE VERY BEGINNING. This is a shot of the spring in the very earliest days, as the small original theater was built. This platform allowed construction workers access to the site so they could put all the pieces in place. The next photograph shows the roof going on the theater. It was a brave undertaking that worked beyond anyone's expectations.

CONSTRUCTION PROGRESS ON THE UNIQUE UNDERWATER THEATER. This was a clear case of finding solutions as they went along. Imagine the challenges that would crop up while attempting to build something no one has ever built before, and doing it on a very limited budget. It took creative minds and nerves of steel to get the job done.

THE VERY FETCHING MARY DARLINGTON FLETCHER IN 1947. Mary Darlington (now Mary Fletcher) of Citrus County, Florida, was the first official mermaid at Weeki Wachee Springs. Newt Perry ran an advertisement in the local papers seeking high school students to perform in a water park. Mary and her brother Ed (known to all and sundry as "Ed the Great") responded and were hired. They remember the experience as hard work but tons of fun. In this picture, Mary is modeling a hot new Catalina swimsuit created for the mermaids. She remembers that one early mermaid, Irma, would sew her own swimwear from color-printed feed sacks, so she could afford dozens of outfits. Irma's family could never figure out why she wanted to feed the chickens so often, but she needed to empty the sacks before she could create a new costume!

GRAND OPENING WOULD DRAW HUNDREDS OF THRILL SEEKERS. It was close quarters in the small theater lobby as Newt Perry interacted between mermaids and audiences when the incredible attraction opened its doors. At first, the girls only demonstrated skills like eating, drinking, or diving under water. As time went on, the demo turned into a series of full-fledged showbiz productions that became more elaborate with each passing year.

BUILDING A ROTUNDA FOR PANORAMA SHOOTS. In 1947, Hollywood came to Florida with a magical cast including Mr. Peabody (William Powell) and glamorous starlet-gone-mermaid Ann Blyth. A round platform built over the spring allowed camera crews to shoot panoramas. The panoramas were composites created by taking a picture, turning the camera slightly, shooting again and continuing to create a group of images that could be stitched together and printed as one.

BUILDING A POPULAR ATTRACTION YEAR BY YEAR, 1951. Once Route 19 from Citrus County to Tarpon Springs was miles of scrub, woods, and sunny skies. As America took to the roads in droves, East Coasters, Midwesterners, and West Coasters flocked to Florida. Entrepreneurs established the Sunshine State's character with roadside pleasures like Weeki Wachee and Silver Springs, complete with bathhouses and snack bars like these.

BEFORE THEY HAD FLIPPERS, THEY HAD LEGS. In early days, the word "mermaid" was used loosely. The graceful swimmers had human legs. As the theme took hold and the idea grew, costumes with fish-flipper tails seemed natural. Here a mermaid performs one popular underwater trick. Audiences love seeing Neptune's daughters magically gather schools of fish (attracted by air-hose bubbles) and provide a snack for their finned friends.

WEEKI WACHEE IN THE NEWS, c. 1952. People flocked to gaze at mystical visions of ladies who "lived" in the sea, or at least the river. Hollywood was never far behind any phenomenon and, from the beginning, film crews were a constant. This group, pictured by Warner Pathe, makers of newsreels, seems to be completely happy with their assignment for this particular day. The mermaid is Mary Darlington.

PROVING AIR MAKES PEOPLE BUOYANT. Just like on the television show *Watch Mr. Wizard*, the mermaids were not above using entertainment to present a little science lesson. If you fill your lungs with air, you rise; blow it out and you sink, as Patsy Boyett shows here. This is how mermaids synchronize their position in the water as they work together in various routines.

HOW DO MERMAIDS BREATHE UNDER WATER? c. 1949. Underwater breathing was a challenge, but Newton Perry, the wizard behind the concept, overcame it. In 1946, Perry leased the land and built the first theater, 15 feet down. He applied what he had learned as a navy dive instructor to his mermaid idea, using compressed air piped via an air-hose that could be concealed behind plants or rocks. He developed a stringent training course for his mermaids (and a strong code of behavioral ethics, too!). One of the original sea-maids demonstrates the use of her breathing apparatus in this photograph. In the 1940s, the area of Florida now known as Spring Hill, where Weeki Wachee Park is located, was farmland and wetlands. Perry's dream park was the only reason people ever stopped off in the area. According to Jill Roddis, who worked in the park for about a quarter-century, there was never a problem recruiting new mermaids—"Every little girl wants to be a mermaid, doesn't she?"

A BOAT AND A RIVER—TOURISM BEGINS, 1930s. From the early 20th century, Florida was promoted by marketing types as the land of exotic beauty and idyllic pastimes. Automobiles became affordable, and Americans fell in love with highway cruising. Savvy entrepreneurs in Tarpon Springs, 25 miles south of Weeki Wachee, catered to tourists and vacationers. Soon each natural spring along what is now known as the Nature Coast (the north-south run along the Gulf of Mexico) became a roadside attraction of one sort or another. People headed for Tarpon, Clearwater, or St. Petersburg on the lookout for local color. Later a famous mouse drew the crowds inland, but for a time, anyone who could maneuver a boat in a waterway and had the gift of gab could make a living. The fellows pictured here did not have mermaids, but they did just fine.

No Hazard Pay, but Lots of Exciting Job Assignments. There was not much budget for hiring outside help, so mermaids and mermen did double and triple duty, learning lots of skills on the job. In this shot, a merman—probably Ed Darlington—prepares underwater props and equipment for the next show. Chances are he went topside afterward and was assigned to do the show's commentary, take tickets, or run the snack concession.

Mermaid's-Eye View, c. 1949. This interesting point of view shows how the audience looks to a mermaid. The sea lady feeds a school of fish between sips at her air-hose. Management decided that mermaids had to have long hair—their tresses looked so pretty swaying gently in the current. The most unwelcome guests were alligators that might wander in. Spotters on the banks tried to head them off.

SUCCESS WAS QUICK, EXPANSION INEVITABLE, 1940s. This company vehicle may have been the forerunner of today's SUVs. As theme parks caught on, Mr. Perry's brainchild attracted enormous attention. In fact, the park was purchased in 1959 by American Broadcasting Company (ABC), who began a multi-million-dollar, 20-year improvement project. There was no doubt this unique little idea was the start of something big, and it became world-renowned.

COVETED CAREER, c. 1950. Weeki Wachee jobs were unique. This unidentified man was pleased to spend a sunny day taking care of business. Look closely at how clear the water is. This rowboat is poised over the spring, said to be bottomless and 74.23 degrees year-round. The most dangerous part of the performance was always a mermaid's dive to 117 feet deep.

24

BASEBALL HALL-OF-FAMER POSES FOR THE CAMERAS, c. 1949. Weeki Wachee drew a host of celebrities. One of the most renowned catchers and team managers of the time, Connie Mack, visited more than once. Here he poses with family members after touring the property. From left to right are Connie Mack, Mrs. Catherine Mack, and unidentified companions. Mack was born in 1868 and elected to the Baseball Hall of Fame in 1937. His career included affiliations with teams in Washington and Buffalo and two years with the Pittsburgh Pirates (1894–1896). Connie Mack's main team was the Philadelphia Athletics. When someone said the Athletics were a "white elephant," Connie retorted by quickly adopting an elephant for team mascot, and the Oakland A's still use the symbol. The Mack family is deeply connected to Florida and its communities. Mack's grandson, Connie, became a U.S. congressman for Florida.

PRETTY AS A PICTURE POSTCARD. A picture postcard is just what this image is. The ladies are the early mermaids or the Aquabelles, a St. Petersburg group that preceded the first mermaids. In the background is the original theater, on the far shore of the main pool. This was in the very early 1950s or the end of the 1940s.

LONG BEFORE THEY HAD TAILS. This is one of the earliest mermaids doing her thing. It is a good look at the bubbles created by the air-hose and at one of the interesting activities performed underwater. It is not known who thought up all these tricks, but it surely wasn't just one person. Most likely, a collaboration of great minds in a think tank came up with the never-ending stream of ideas.

SWAN DIVES IN COLD, COLD WATER, c. 1948. Today mermaids enter the water via a fireman-type pole through a vertical tube. They used to line up on the bank of the basin, where a lively water park, Buccaneer Bay, now stands. On cue, they would dive into chilly water and swoop toward the theater window. They were all smiles and grace, never letting the audience know about teeth chattering and rapidly rising goosebumps.

HAVING A GREAT TIME, DON'T YOU WISH YOU WERE A MERMAID? This is a personal memento from one mermaid, Bunny (left), to another, Mary (right). These athletic young women and their comrades had to pass a try-out swim test, train for 8 to 12 weeks, and master a breath-defying 117-foot dive before they could truly call themselves "mermaids."

BUD BOYETT STALKING THE WILD EEL GRASS, 1954. The Boyett family is closely connected to Weeki Wachee's early days and the tourist business in Hernando County. Patsy Boyett was a mermaid. The family owns and operates a charming roadside attraction called Boyett's Grove in Brooksville, Florida. Boyett's Grove has a small zoo, historical photographs, and citrus specialties. It's fun and nostalgic.

VINTAGE POSTCARD: BEAUTIES AND THE BEACH, 1950S. This is the east shore—a perfect photo opportunity with a terrific backdrop of the theater. Through the years, a series of wonderful postcards marked the history of the park. The cards often turn up for sale on Internet auctions. Roadside exhibits in Florida's old days included zoos, jungles, aquariums, volcanoes, boat trips, skiing, the first mini-golf (Goofy Golf), and the first trained dolphin show (Marine Land, 1951).

DRINKING A COLA UNDER THE SEA, c. 1950. Mermaids live underwater, and so must have the same skills we have on land, right? One of the most popular demonstrations was a beautiful girl drinking a beverage underwater. The beverage was Grapette, manufactured in Malvern, Arkansas, since 1939. The big-name colas and most other bottled drinks were too bubbly, causing mermaid bloat. You can still get Grapette in some Southern stores or markets.

THREE MAIDS AND A MAN. This gentleman is Ricou Browning, a past Olympic swimmer who played Gill-Man in *Creature from the Black Lagoon* in 1954. He helped clear land when the park was developed and became a performer and producer for some years. Browning, like others who began at Weeki, went on to work in films and television programs. Born in Florida, he is a well-known celebrity and community participant.

79

A Former Mermaid as she Appeared Yesterday, 1950. Here is Mary Darlington Fletcher, a very significant mermaid. She models a new style of swimsuit, probably for some print advertising. This is a beautiful picture of a stunning young woman, and just below is a recent shot of her in the 21st century.

The First Mermaid, Mary, in a Formal Portrait, c. 2000. Each year, the current crew of mermaids finds it inspiring to see the former mermaids still performing in their own monthly productions. They do their own choreography and writing; they rehearse weekly. The ladies are healthy, fit, and still as enthusiastic as they ever were. Many have regular jobs, though some are retired. Mary is a real-estate broker by day and attends as many reunions as she can.

EARLY ENTREPRENEUR TAKING ADVANTAGE OF A NATURAL OPPORTUNITY, c. 1960. This place was a common sight to those who lived on the river. Fred caught fresh fish and sold them to those who knew how to find his place. The going rate was just 15¢ per pound, and you could not get a fresher dinner. The cabin might have been pretty rustic, but the life was probably healthy and peaceful.

EXTRA! WEEKI WACHEE GETS NEWSPAPER, c. 1983. At the height of popularity, the mermaid park seemed destined to be around forever. Their periodical, called *The Entertainer*, covered newsy bits from Weeki Wachee and Silver Springs Park, north of Ocala. *Sea Hunt* was filmed at Weeki's sister facility, Silver Springs, which boasted a fleet of glass-bottom boats and a large group of aquamarine-colored pools.

FANTASY, THE STUFF OF MERMAID DREAMS, c. 1950. This set—a mermaid castle and trees underwater—is a publicity picture of Ann Blyth for *Mr. Peabody and the Mermaid*, about a 50-year-old man who regained his youth through love of a mermaid. It had one blooper: in the underwater fight scene, the fishtail costume can be seen coming detached from the mermaid's back.

Two

The 1950s and the 1960s

Faulkner showed us his version of the South and won a Nobel Prize, Joe McCarthy claimed he personally knew 200 commies, Truman policed Korea, and an intricate highway system webbed across the nation. Dr. Salk gave us the polio vaccine. Rock and roll was born. Teens in rural Hernando County, Florida, and nearby areas became enamored of a kitschy little forerunner to theme parks called Weeki Wachee, home of the mermaids.

Television, the one-eyed monster, coughed up *Your Show of Shows*, Mary Martin's *Peter Pan*, *Red Skelton*, and *Winkie Dink*. News happened right before our eyes. People grew wary of Russia and fearful of nuclear attack. Fallout-proof bomb shelters cropped up, while children crawled under school desks. We stood dumbfounded when John F. Kennedy's life was snuffed out on national television.

Cocoa Beach was made famous by a TV comedy about a mythical woman. Not a mermaid, she was a genie living in a bottle on *I Dream of Jeannie*. Florida was steeped in literary history, home to authors John D. MacDonald, Ernest Hemingway, Marjorie Kinnan Rawlings, and Zora Neal Hurston, and much earlier, Mark Twain. Movies made here included *The Greatest Show on Earth*, *Spring Fever*, *Follow That Dream*, and *The Incredible Mr. Limpet*. Musically, Jimmy Buffet and David Sanborn called Florida home.

The Beatles spearheaded the British Invasion, changing the popular music scene forever. Skirts got shorter and the women's liberation movement popped up. Women turned outward from home and hearth to career, personal satisfaction, and creative expression. Young women of Florida were no exception; their grandmothers would have disapproved of scantily clad females making an underwater exhibition of themselves. Weeki Wachee attracted attention from New York to California. Television commercials about live mermaids were seen everywhere, including Chicago, where Two Ton Baker's Saturday morning children's show offered film clips of lovely ladies who seemed to live underwater.

Florida farms and citrus groves flourished; some were sold to housing developers and subdivisions sprouted like alien crops, echoing the first suburban tract, Levittown. Communities built schools, churches, and highways to accommodate the new breed of settlers trickling to Florida's life in paradise. Later the trickle would be a flood.

NATURAL BEAUTY ADDED TO HUMAN ENTREPRENEURSHIP. Here is a terrific aerial shot of the entire main section of the park in its most popular days. The large building with the corrugated roof is the theater. The white marble mermaid statue is in the center. A tour boat is parked at right. It's possible that turbulence in the water is caused by an ongoing show complete with airhoses and performing merpeople.

> The Weeki Wachee Mermaids pose on the grounds in front of the spring. The underwater theatre can be seen in the background.

TWO KINDS OF NATURAL BEAUTY. Here is a very good shot of the completed original theater. It matches the beauty of the surroundings and the beauty of the mermaids of the day. If this loveliness didn't attract a crowd, what would? This photograph is complete with the caption added by the public relations department of Weeki Wachee Park.

MERMAID REUNION PHOTOGRAPH, 1962. This was a popular year: 47 mermaids pose with one very young merman, sitting in the front row toward the right. Geri Hatcher is sporting the sunglasses (second row, fifth from left). Flo McNabb (second row, seventh from left) is the cute blond in the shirtwaist dress. Her family owned the Weeki Wachee motel across from the park. The 1962 mermaids are wearing flowered sundresses, and the alums might be grouped by era, beginning with the earliest swimmers in the first row. For many years, including the pictured era, most mermaids lived in cozy cottages at the rear of the park acreage. Management felt strongly that young, single women deserved safety and supervision. Rules were strict and included an early curfew. Mermaid Barbara Wynns (1960s swimmer) remembers the water feeling so cold in the winter time that each girl would keep an electric blanket warming her bed. She would do her part of the show and dash back to dive into the warmth before she had to report for other work assignments.

MERMAID REUNION PHOTO, 1963. Thirty-three mermaids and former mermaids, going all the way back to the first one, gathered for a reunion show and a photo opportunity. By 1963, the renovation and expansion program by ABC was on its way to completion. A gorgeous flower garden and a bird of prey show delighted vacationers. The mermaid show included elaborate props and often a story line worthy of a Broadway musical. From left to right are the following: (first row, kneeling) unidentified, Linda Cooper, Kay Finney, Genie Young, Sharon Cyack, unidentified, and Marilyn Reid; (second row) six unidentified mermaids, Mary Fletcher, three unidentified mermaids, Lou Spikes Ferreira, Jeanne Brooks, Ruth ("Ruby Baby") Adams, two unidentified, Carol Pickles, and Geri Hatcher; (third row) Bonnie Georgiadis, Debbie Poore, Tammy Gyarmethy, Ginger Johnson, Nancy Harkness Hunnicutt, Vera Benson Huckaby, Suzanne Palecki, Barbara Bates Jones, and Dee Farmer.

ANOTHER MERMAID REUNION, 1968 OR 1969. The only identification research sources could make for sure is Marilyn Reid, at center in the dotted dress. The two women on the far right wearing harlequin-print swimsuits were appearing in either *Snow White* or *Mermaids on the Moon*, according to the unofficial historian, mermaid Vicki Vergara Smith. One of the gentleman may possibly be Ned Stevens, who Ed Darlington says should be remembered. Ed says, "Ned was trained with Mary and me. He was a fine person—took a leadership role. He was a terrific emcee and added much to the future of the place." Tragically, during his merman years, Ned lost his mother and other family members in a car wreck. He is fondly remembered.

IS IT DAYLIGHT SAVINGS TIME YET? 1970s. Seen is a rare promotional photograph featuring Bonnie Georgiadis's comedic talent and devil-may-care approach. This photograph, though cute as a button, was fairly controversial. The photographer, known as Sparky, enjoyed the animation and distinctive expressions Bonnie could project, but Weeki Wachee's public-relations director objected to the distraction from his vision of the mermaid image. Management won—this was the last cross-eyed pose allowed.

AND A GOOD TIME WAS HAD BY ALL. If you pay attention to the images in this book, you'll see that most always, these water workers were just having a great time. They established life-long friendships, created a world-famous mystique, and generally enjoyed themselves. Here you see, from left to right, Ed Darlington, Mary Darlington Fletcher, Bunny Eppley, and Mert Rakes in the summer of 1972.

THE AMAZING FEATS AT THE SPRINGS, 1940S. The first theater was small and simple, but later it was almost a Herculean task to create the new state-of-the-art theater underwater, where only fish and alligators had gone before. It took months of coordinating work efforts and over $1 million, but the results provided generations of entertainment, a legacy of Hollywood film locations, and employment for hundreds of people.

A GALAXY OF STARS CAME TO FLORIDA FOR THE LUSH SCENERY. Hollywood movie companies began their love affair with the west Central Florida area's beauty about 1916, with the filming of the silent film *Seven Swans*. *Seven Swans* was filmed at Weeki's once-sister park near Ocala, Silver Springs, as was Esther Williams's movie *Jupiter's Darling*. From the early days of Johnny Weismueller's *Tarzan* to the present, both parks have been desirable destinations for directors who wanted accessible exotic scenery.

39

A School of Mermaids Breaks for Coffee with Arthur, 1963. Arthur Godfrey visited Weeki Wachee in conjunction with the opening of *The Incredible Mr. Limpet* with Don Knotts. Mermaids say Godfrey was warm and friendly. The DVD release of the Knotts movie includes a ten-minute featurette, *Weekend at Weeki Wachee*.

Celebrities Were an Everyday Sight. Some thought Ann Blyth was one of the prettiest. In fact, Ed Darlington says he was so enamored of her that he sometimes just followed her around, feeling like he was in a daze. He even came close to tumbling in more than once. Other Hollywood ladies that visited included Esther Williams and Deborah Walley, star of *Gidget Goes Hawaiian* and other Disney productions of the era.

HOPEFULLY THESE CREATURES WERE NEVER ACTUALLY SEEN IN THE PARK. But the owners of this exhibit claimed 10,000 of the world's most beautiful and unusual invertebrates from all tropical areas of the globe inhabited the May Natural History Museum. Their marketing material said the museum had spent over 50 years traveling and exploring the world to accumulate "what is now considered one of the world's outstanding collections of giant tropical insects, related creatures and rare artifacts." It isn't likely that anything quite as impressive as this picture was part of the collection, but people flocked to the little building to see its oddities. It was popular to pose for photographs against this magnificent critter. The museum still exists in Colorado and boasts owning 80 years' worth of interesting collectible bugs.

MERMAID REUNION PHOTOGRAPH, 1964. A smaller group of former swimmers turned out for this reunion. As years went by, the group continued to shrink. Local mermaids moved away and lives got too busy for non-locals to get back. Eager young ladies came from nearly every state in the country to apply for this prized position, and it was not unheard of to have daughters follow in their mothers' footsteps. Barbara Wynns says this experience stayed in her heart: "There's nothing like the complete sense of freedom." In this picture are, from left to right, (first row) Vera Huckaby, unidentified, Georgia Underwood, Dottie Meares, Mary Darlington Fletcher, Sharon Cyack, Marilyn Reed Webb, Kay Finney, Betty Chambliss, and Tammy Gyarnathy; (second row) unidentified, Martha Steen Lambert, four unidentified mermaids, Bobbie Sanchez, two unidentified mermaids, Nancy Hunnicutt, Florence McNabb, unidentified, Lou Ferreira, three unidentified mermaids, Genie Brooks, unidentified, and Ginger Johnson.

MERMAIDS AND THE MYSTERY MAN, 1960s. This is a staged publicity shot, and perhaps the man who was supposed to appear wasn't available, so, like blue-screen work in today's high-tech images, he was left out temporarily. His stand-in is a cardboard cutout, but the mermaids are real. Included here are Wanda Patterson, Terry Ryan, Genie Young, Jeanette Perdon, Sandy Lawhun, and Vera Huckaby.

THREE MERMAIDS HAPPILY FIDDLING AROUND. The next time you are out for a swim in a large body of water, preferably one that is about 74 degrees, try the following: put on flippers, a cute swimsuit, or even a heavy, elaborate costume, and play a catchy tune underwater while you are skipping across the sand. Any musical instrument will do. If you succeed, post a message on the mermaid forum at http://www.weekiwachee.com.

THE MORE ELABORATE THE SETS, THE BETTER EVERYONE LIKED IT. It became a sort of competition from the earliest days onward. When Newt Perry began this operation, he loved to brainstorm about what land-based activities could be done underwater as a demonstration for travelers who stopped to see the live mermaids. This is perhaps one of the most charming: a school of mermaids. If mermaids are half woman and half fish, then certainly they must have schools underwater, like the fish, and schools for learning, like the humans. Note the bricks keeping chairs from drifting away on the current. From left to right are Carrie Drapp, Marilyn Reed, Nancy Harkness Hunnicutt, and Faye Watson in 1961.

MARDI GRAS, UNDERWATER STYLE. One of the most popular themes was Carnival, or Mardi Gras. Modeled after the Brazilian Carnival season and, of course, the New Orleans party of parties, harlequin costumes, beads, and pirate sets looked terrific in the clear blue water. These ladies appear to be having a great time.

MERMAIL—NEITHER RAIN, SLEET, AND CERTAINLY NOT SNOW. Mermail travels more slowly than snail-mail; mermail just drifts on currents, they say. This postcard says, "Dear John, having a big time in Florida . . . Mary." The mermaid is Genie Young. Genie's mother did accounting for Weeki, her dad worked in the shop, and her sister was a mermaid, too. Her brother-in-law was a driver, and her brother, Mickey, did security.

15

ANOTHER CARNIVAL SCENE. In this image, the mermaids are more clearly visible. On the right is one of the Harding twins. This is a great view of the costumes and gives an idea of how the air-hose is used while performing: the mermaid will sip some air then drop the hose. The clown heads are fine examples of the craftsmanship that went into the props and sets.

ABOVE THE WATER AND BELOW, THE MERMAIDS WERE ALWAYS UP FOR AN ADVENTURE. For publicity events, sometimes the mermaids even performed above the water. This is a 1970s scene with some lovely swimmers *sans* tails rescuing a sunken treasure from the silvery depths of the river. In the old days, real pirates were often known to sail the Weeki Wachee coast looking for fresh water.

THERE SHE IS, MISS UNIVERSE 1965. Miss Greece, Kiriaki (Corinna) Tsopei, was crowned Miss Universe and visited Weeki Wachee. News reports characterized her as having a robust appetite, saying she ate potatoes three times a day. In the pageant, Edna Park, Nigeria's first Miss Universe candidate, collapsed after not hearing her name as a semifinalist, but there were no mishaps when the Greek beauty visited in Florida.

INTERNATIONAL MERMAIDS. In the 1970s, the mermaid roster included two ladies from Japan. Later, a venue similar to Weeki Wachee opened in Japan. Pictured is Shinko Akasofu. Shinko loved her job and her adopted country so much that she never left. She lives in New York with her husband and a daughter. Mermaid Sandra Schimelfening, now of Seattle, thought Shinko was a lovely person.

47

CLEAR WATERS MAKE GORGEOUS FILM EFFECTS. Lamar Boren, the famed cinematographer, spent some time deep in the uncomfortably chilly waters, but it was worth it to him. Moviegoers and television fans always want realism, and he made every effort to give it to them. Even if his subject matter was mermaid life, the fantasy world had to look real.

THE PERFECT CAMERA, THE PERFECT SUBJECT. Ask any photographer and she'll tell you a Rollei is still one of the finest cameras you can use. Ask any male photographer and he'll tell you a mermaid like Vera Huckaby is the best subject; she beats the heck out of a manatee for eye appeal, anyway. Folklore in Florida says the mermaid legend may have begun when some sailors, long at sea, sighted a manatee breaking the waves on a dark evening.

BRING HALF THE CLOTHES AND TWICE THE MONEY. That is advice given to first-time travelers, and it might have helped the film companies, too. Cinematographer Lamar Boren, pictured, had a conversation with makeup genius Buddy Westmore. They concluded, "We began with 2 weeks and $500 to make a mermaid picture. So far, we used 12 weeks and $14,000." Today's movie budgets go into millions of dollars, Lamar.

HOLLYWOOD NOTABLES BUSY PRODUCING POPULAR ENTERTAINMENT, c. 1960. Noted feature cinematographer and director of photography Lamar Boren was often seen at Weeki Wachee filming television programs and movie scenes. He gets credit for his work on *Flipper*, *The Old Man and the Sea*, and *Sea Hunt*. Boren enjoyed filming at Weeki Wachee because of the clear water and varied scenery that looked exotic but was completely accessible and far safer than far-off islands.

HEART THROB GLEN CORBETT OF ROUTE 66 CERTAINLY GOT MERMAIDS' ATTENTION. Corbett is the tall, dark, and handsome guy at center. The episode "Cruelest Sea of All" (#87, 1963) had Corbett and Martin Milner working at Weeki Wachee and encountering a real mermaid. Corbett falls for her but is skeptical about her hints that she isn't just a performer. Ultimately he realizes the sad truth, but she is gone for good.

GET YOUR KICKS ON ROUTE 66. Hollywood stars of television and movie fame, Martin Milner and Diane Baker grab a moment to relax between takes on the shooting of Route 66. Most people thought the television show was filmed in California. The sculpture of the princess of Weeki Wachee was a favorite place to aim a camera, so nearly everyone had his or her photograph taken with her.

"THE CRUELEST SEA OF ALL," 1960s. This *Route 66* episode was created by some of Hollywood's most productive and creative minds. Actress Diane Baker, who was also in the movie *Inherit the Wind*, watches as Lamar Boren works with a camera. Stirling Silliphant wrote the script for this episode and may be in the background here, with sunglasses. He also wrote screenplays for *The Towering Inferno* and *The Poseidon Adventure*.

HIGH TECH IS NOT JUST COMPUTERS. Not all movie and television scenes were actually filmed underwater. A fully equipped camera room was constructed in the 1960s. At least four movie companies and countless television programs used the facilities. Not all were Hollywood companies. Here is a photographer from one of Florida's oldest television stations. The trend continues today, and companies from overseas come for projects from television to music videos.

THE KING OF ROCK AND ROLL WITH A PRINCESS OF THE SEA, 1961. The King takes a break from filming *Follow That Dream* in Yankeetown, Florida, about 30 miles north of Weeki Wachee. He made a few appearances around Hernando County, hobnobbed with the mermaids, and posed for pictures. It was pretty unbelievable for these small-town Florida girls to meet Elvis.

FLORIDA WAS BLOWN AWAY WHEN ELVIS CAME TO MAKE A MOVIE. The flurry of excitement created quite a stir. In fact, State Route 40, the highway more or less featured in Elvis's movie, was renamed "*Follow That Dream* Highway" in honor of the time when the Mirisch Company came to town. You can still find the sign in Yankeetown. There is more than one Elvis landmark up there.

AMERICAN BEAUTIES. This was the creation of "teen" culture. Until the 1950s, no one called them "teens." After Bill Hailey and the Comets smashed charts with "Rock Around the Clock" and Elvis swiveled his pelvis, someone noticed teens had money to spend. Soon, they had their own music, their favorite foods (burgers and colas), and fashion rules. These girls were totally hip: head scarf, rolled jeans, pedal pushers, and penny loafers.

ONE OF THE FIRST AUDIENCES AT THE UNDERWATER THEATER. This was shot in 1949—look closely at the ladies' clothes: wide-legged pants, flowered dresses, hats. The gentlemen are all wearing business-type shirts, not a printed tee-shirt in the bunch. This group is probably waiting to see one of the very first underwater demonstrations in the springs, or anywhere in the world, for that matter.

THEY LIVED, ATE, AND PLAYED ON THE JOB. Like large mining companies in the early days of America, the park paid mermaids in company scrip, or "clams," units of compensation for some of their work. Other employees worked for food and lodging. Seated from left to right are Bonnie Georgiadis, Trudy Jennings, DeDe Parmer, and Suzanne Palecki in the Patio Restaurant.

WHERE DO LITTLE MERMAIDS COME FROM? They come from the same place as little humans, of course. Mermaiding was really a way of life, and these young women grew up together. They finished school, married, and had families; sometimes, their children grew up to be mermaids. This is a baby shower given by the tailed wonders for sister swimmer Genie Young. From left to right are unidentified, Linda Mashburn, Young, Susie Spencer, unidentified, and Tracy Williams.

FROM 1949 THROUGH THE 21ST CENTURY, MERMAIDS CARE FOR FINNED FRIENDS. It is a popular event in the shows: the mermaid (Barbara Wynns) sits quietly underwater and schools of fish gather around her. She will offer them a little snack as her hair drifts silkily around her face and air bubbles percolate to the surface. This is a vision that has fueled lifelong memories for little girls and boys and for adults.

ALL ABOARD, ALL ABOARD—HOW TO SEE THE SEA. Silver Springs Park and other sources credit Hullam Jones with inventing glass-bottom boats in 1878 by putting a see-through bottom in a canoe. Now you find glass-bottomed boats from Key West to Pensacola and in movies, including a 1966 Doris Day flick named after the boat. If you have not experienced this, put it on your to-do list.

JOHN HAMLET, A HOME-GROWN CELEBRITY. Well-known naturalist John Hamlet, pictured here, is described as "one of the kindest people there ever was" by mermaid Bonnie Georgiadis of Tarpon Springs. Hamlet was the driving force behind all of the nature exhibits at Weeki Wachee. Management built a place for him to do animal behavior research and train park creatures. He designed a safari outpost exhibit (the background of this shot), a Seminole village in the woods, and several animal habitats. Boats and a covered wagon took visitors to those sites. Those fascinating exhibits are now long gone; some were destroyed by fire and some were victims of land sales throughout the years. Hamlet married mermaid Terry Ryan. Pulitzer Prize–winner and renowned outdoor writer W. Horace Carter wrote a biography of Hamlet called *Land That I Love*.

STALKING THE WILD SWAMP CREATURES. John Hamlet, a fascinating man, was primarily responsible for the unique natural character of the park. He spent a lot of time exploring the swamps and rivers. His goals were to find material for the books he wrote, like *Our Vanishing Wilderness* (with Shelly Grossman, a talented nature photographer), and to invent more and better exhibits for park visitors to enjoy.

CALL HIM THE BIRDMAN OF FLORIDA. Florida has incredible birds, some of which you cannot find elsewhere. They range in color from deepest indigo to brilliant pink. Hamlet made it his concern to find and rescue injured birds and provide habitats for healthy ones. Legends say birds came to this river to heal injuries long ago. Hamlet wrote the book *Birds of Prey of the World* with Shelly and Mary Louise Grossman.

COLLECTING NATURE SPECIMENS AND STUDYING HABITATS. Important work and study were part of everyday life. John Hamlet gathers tiny specimens to add to his study collection. Tragically much of his work was lost and exhibits destroyed when a gang of juvenile delinquents spent several days setting forest fires on the property. Everyone rallied to fight those fires with shovels and anything they could think of to save the park.

IN THE PARK'S HEYDAY, VISITORS CAME FROM EVERYWHERE. The Hernando County Airport, still operating today, was the best way for celebrities to get to Weeki Wachee from Hollywood or faraway places. Private planes came and went quite often. The plane and automobile in this shot are terrifically nostalgic and typical of the glamorous times of starlets and leading men.

WHAT AN EXCELLENT SEND OFF! These young guys were just inducted into the army when this was taken. They could not have had a more enjoyable going-away party. The mermaids are, from left to right, Brenda Indermuel, Marilyn Reed, Nancy Harkness Hunnicutt, Penny Briggs, Barbara Owens (Brenda's sister), and Bonnie Georgiadis. The enlistees are from Brooksville, Florida: from left to right, Curt Hall, Mike O'Busek, and Jackie Hood.

FIVE TELEVISION STARS, 15 MINUTES OF FAME, AND A MERMAID. Think back; do you remember popular shows *To Tell the Truth* and *What's My Line?* One mermaid appeared on both. From left to right are Bill Cullen, Arlene Dahl, Rosie Grier, Kitty Carlisle, Art Linkletter, Bonnie Georgiadis, and two imposters. None of the panelists guessed Bonnie's identity or occupation on the programs. She also appeared on the game show *Missing Links*.

THE DINER. Actually, this is a photo of the restaurant–snack shop at its best. Very reminiscent of a 1960s diner, the checkered asphalt tile is familiar for the era. Note the wonderfully nostalgic furniture and light fixtures. The plants are probably real. Doesn't it feel like something out of *Happy Days*? It was not this quiet very often in that time.

LIVING TOGETHER ON THE RIVER. Pretty regularly, people cruised up and down the river. There was not exactly a traffic jam, but boats appeared often enough to be noticed by the wildlife. It was obvious that staff, whether maintenance or nature staff, were careful to respect the natural residents of the area. Neither birds nor beasts seemed much intimidated by the traffic.

HE'S NOT DICTATING DRYLY HUMOROUS REMARKS. Once upon a time, almost every movie house ran newsreels before the double feature played. You really got your 35¢ worth when you went to the show. Taken from a nationally aired Universal Pictures newsreel, this fantastic shot underlines to what extent dreamers and creators at Weeki went in their quest for the unique. In full business garb, including shoes and suit, this would-be executive smokes a cigar while dictating to his alluring secretary. It must have been tough trying to roll that bond paper through the typewriter. And how does that man keep his stogey going? It must have been fun and a really big headache to create props that would stay where they were put and behave in an expected manner once they were established in an underwater world.

PART OF FLORIDA'S AQUIFER. Weeki Wachee Springs, a traditional site for fun, drama, and glamorous imagination, is a vital part of the local aquifer. The springs are in an underground labyrinth of lacy limestone caves and formations that hold Florida's daily water supply. This spring is bowl shaped. They say the water is clean enough to drink as it is, though development and an increasing population affects its condition.

THE EXECUTION OF A GRACEFUL DANCE COMPONENT. The next four images show in detail the beginning, middle, and finish of a typical mermaid underwater dance move. The movements needed to be precise and graceful. Breathing had to be controlled and timed so the performer could, between dance elements, take quick sips of air from hoses.

UPSIDE DOWN AND SIPPING AIR. The swimmer is upside down now and appears to be taking advantage of this moment to replenish her air supply through the hose system. The girls are taught to accomplish this without drawing the audience's attention to the hose. The water is chilly and the performance demanding. It takes skill and stamina to do this several times a day.

FULL CIRCLE NOW. These water dancers can be 16 to 20 feet underwater. There are potential problems. It is not unusual to become disoriented when they are upside down. In severe weather, potential lightning strikes are a concern. Underwater props and lifts might malfunction, and mermaids have to improvise and keep going. A girl might inadvertently drop her air hose, but the show went on.

AND A VERY GRACEFUL FINISH. Note the diving mask. The performers don't use them anymore; they prefer the natural look of bare faces. The Florida Department of Environmental Protection says the spring discharges from the bottom of a deep cone-shaped dip. The depth to the center of the bowl is nearly 50 feet. The pool in these images is 160 feet east to west and 210 feet north to south. The center bottom is bare limestone, but the pool edges are not rocky. The very clear water has a pleasant light greenish-blue cast, with water bubbling a bit in the center. The basin bottom is covered with slippery algae, and there are some grasses growing in the pool. There's an abundance of various fish and aquatic turtles, any of whom might appear in a cameo or even a starring role in a given performance.

A LOOK AT COSTUME STYLES ON MERMAIDS OF THE 1970S. Though the identifications in this shot are not certain, it is thought the mermaids are, from left to right, (first row) in American Indian costume, Peggy Westmoreland, then Wendy Johnson; (second row) Sue Kovac with the tambourine, Vera Huckaby, and Karen Sykes wearing the tutu; (third row) Ruth Johnson, unidentified, and Barbara Wynns standing up highest. These costumes represent some of the variety that were used in the shows. During the 1970s, the company adapted popular Broadway themes, movie themes, and television themes. Mermaids like Bonnie Georgiadis worked hard on costumes, sets, scripts, and music. Everyone played multiple roles in making this concept work for the audiences. Professional pride was evident, and they paid close attention to details.

SWEET HITCHHIKERS POSING TO SHOW OFF CUSTOM-MADE SWIMSUITS. More than one manufacturer of swimwear was pleased to provide swimsuits designed exclusively for the mermaids. The suits were only worn on "official business," and the creators received wonderful exposure for their products. As time went on, though, mermaids were seldom seen around the spring without their six-foot tails.

AN ENGAGING REMINDER OF DAYLIGHT SAVINGS TIME. By the 1970s and 1980s, it had become a tradition for local newspapers to run a photograph of a mermaid reminding everyone about time to move the clocks ahead or back for daylight savings time. Unfortunately, only two of these images have been preserved. This one is Marty Warcham, according to the historians. The pictures would make an interesting photo album, wouldn't they?

MERMAIDS GENIE AND SUE DEMONSTRATE TRADITIONAL MERMAID SKILLS, 1960S. Sue is drinking what is probably Grapette, and Genie is eating a banana. Someone said the park used to use about a ton of bananas each year, between feeding the animals and providing props for the mermaids. The swimsuits were created by Alix for the mermaids and donated to the park by the company.

THE CITY OF LIVE MERMAIDS. Weeki Wachee City can be found on any map of Florida communities. In 1966, the park and surroundings incorporated as a city to put the park's name on the map. At one time, by census, the population was about 50; now it's 9. The city is about two square miles at 28.5 degrees north latitude and 82.5 west longitude. Pictured is the city seal.

67

CONGO BELLE AND THE CLEAR REFLECTION OF TREES MIRRORED IN GLASS-LIKE WATER. The Weeki Wachee flows west for five miles into the Gulf. The nearest high ground is rolling sand hills rising to 15 feet above the water level. Every bit of uplands and land near the spring is developed, which takes a toll on the water quality. U.S. 19 is 225 feet from the shore.

ON WITH THE SHOW. As time went on and the shows got more and more complicated, the sets got more difficult to install. Here are some of the pieces of one set. It was lowered underwater in parts then assembled and installed down there. The question is, did the workers get hazard pay? Many sets were built by Skimp Cumber of Sarasota.

THE FINISHED PRODUCT, READY TO BE DEEP-SIXED. This castle was destined to become part of the underwater world of mermaid city. The photograph was probably done for a publicity piece. The next step is to haul it off the ground with a crane and settle it into its home at the bottom of the spring.

A DAY FOR ANY FAMILY TO REMEMBER FOR A LIFETIME. If you've ever been to a large theme park, you probably ended up with sticker shock after paying admission and then paying for souvenirs and food. At Weeki Wachee, families like this one had a great time without worrying too much about the budget. It was a pleasant day in the country, with the added benefit of mermaids for company.

A DIFFERENT APPROACH IN HER EASTER BONNET, 1960s. Bonnie Staley Georgiadis was, and is, a consummate mermaid. Anywhere near water, she could be campy or gorgeous. At home in front of the camera, she could be counted on to be funny, original, or sophisticated as the situation required. Photographers adored her; management sometimes raised an eyebrow over "image," and audiences were delighted! She was just as at home behind the camera, often doubling as a still photographer for the mermaid operation. To this day, Bonnie loves mermaids, animals, and photographs. She has a tremendous collection of wildlife and mermaid photographs and memorabilia. She has had her hand in Weeki Wachee for more than 30 years and sees no end to it in the near future.

WHAT EXACTLY IS AN OTTERTORIUM? Created by on-site naturalists, this contraption was a wow with folks who took the early boat cruises down the Weeki Wachee River. Otter food was dropped into the tank and the little creatures came to dinner as the boat pulled up to the riverbank. It wasn't generally a mermaid attraction, but this photograph was taken at the grand opening of the Ottertorium, just for fun.

ANOTHER PUBLICITY OPPORTUNITY TO KEEP VISITORS COMING IN DROVES. In the center is Jack Mahon, head of the public relations and marketing departments that helped make Weeki Wachee a phenomenon. Pictured are, from left to right, (first row) Terry Ryan Hamlet, Shirley Walls, Lou Spikes, and Marilyn Reed Webb; (second row) Vicki Smith, Carmen Jones, Mary Sue Clay, Mahon, Jeanette Purdon, Sandy Lawhun, Nancy Hunnicutt, and Bonnie Georgiadis.

THIS IS WHAT IT LOOKS LIKE TO BE IN THE AUDIENCE. Mermaid Barbara Wynns is doing what every mermaid since the very beginning has done: providing entertainment for the audience and a snack for her finned friend. You can see how mesmerized the crowd is. Some of these friends at Weeki were such regulars that the mermaids named them.

A BILLBOARD AT THE BOTTOM OF THE SEA. Smart advertisers go where the people are, and in its day, the "City of Mermaids" was certainly where the people were. Who would have thought that an advertisement underwater could get great exposure and instant response? This fund-raiser was the successful forerunner of many others.

72

Entire Crew from the Late 1960s. Louis Finske, standing at center in the white shirt, was head of Florida Leisure Attractions, the company who owned the park at this time. Pictured are, from left to right, (first row) maintenance staff; the sixth man from left is Ernie Ferrera, and the rest are gardeners; (second row) seven maintenance workers; three gift-shop ladies; Linda Seeley; three unidentified employees; Finske; Genie Young; Vera Huckaby; five unidentified people; (in suits) Jack Mahon, head of public relations; Tom Brinzo, park manager; and Frank Lones, motel manager; (third row) Peggy Westmoreland (sister of Genie Young); Cheryl Rhodes; Ginger Johnson; unidentified; Karen Drapp; unidentified; Bonnie Georgiadis; and two unidentified people. Many of these photographs were taken for news releases. Like all good marketing managers, Jack Mahon believed in making a lot of opportunities to get in print and on television.

VERY LARGE BIRD'S-EYE VIEW? This is just a little bit different from the typical mermaid publicity photograph. Starting at the mermaid in the flowered suit, and moving clockwise are mermaids Peggy Westmoreland, Genie Young, Diane Wingate, unidentified, Dixie Clayton, and Bonnie Staley Georgiadis.

SERIOUS BUSINESS NEEDS SERIOUS PRACTICE. New mermaids had to learn the right technique for hose-breathing, and established mermaids had to practice. From left to right, Wanda Patterson Weeks and Gail Shower watch as Bonnie Georgiadis draws air deeply, filling her lungs with each breath. It's not an easy feat when you are underwater and trying to remember your routine. No one ever put safety at less than priority-one importance.

ADAGIO, ANOTHER VIEW. This pose is one everyone learned. It is a 50-year tradition at Weeki Wachee. The pose has been used in RKO and MovieTone newsreels, 20th-Century Fox shorts, and numerous print articles. The Aquabelles were the first to use it, but the mermaids perfected it. The Aquabelles had no masks or air hoses. Everything they did had to be done on a deep breath of air. Mermaid Barbara Wynns said, "Mastering ballet poses was hard, especially when with high heels or ballet shoes in the water. But the hardest part was learning to use the air hose. That was a new skill for everyone. Some took six months to learn." Pictured are Genie Young (bottom) and Dee Dee Parmer.

An Idyllic Way of Life if You Don't Mind Cold Water, c. 1965. Can you imagine how exotic it would be for a young woman (or man) to get a job that included a quaint cottage on the edge of the river? It was a one-of-a-kind opportunity. The woods echoed with the sounds of monkeys, alligators, tropical birds, and the river itself. People who lived north on the river would come downstream to wash their hair in clear, soft water. Girls came from everywhere to try out for these jobs—from McAllen, Texas, to Huntington Beach, California, and from Brooklyn to Tampa, as well as everywhere in between. Always, the expectation was for professional decorum and excellent conduct. Stories are told of precocious teen pranks that got mermaids suspended or banned once or twice, but in general, all was well.

Three

THE 1970S AND THE 1980S

The time was characterized by a desire to shake off traditional boundaries and explore new ideas. There was an oil crisis. The economy slipped, politicians finagled, and Americans were a little self-absorbed. The 1970s were the "me" decade, and the 1980s went conservative.

Embroiled in war, America needed distraction at home. Throughout Florida, vacationers found roadside attractions like Silver Springs, Monkey Island, Dinosaurland, Bok Tower, Cypress Gardens, Marineland, and Gatorland. Hotels, motels, and mobile parks cropped up everywhere.

The muses and the fates were with Newt Perry and his partner when they had the farsightedness to sell the whole caboodle to ABC Entertainment a decade earlier. At the end of 1971, the mouse migrated to the Sunshine State, and everything changed.

Roadside attractions struggled with dwindling audiences. Tourists loved newer one-stop destinations that seduced them with everything they needed on huge properties. The mermaid city did fine through the 1980s with exotic animals, an American Indian village exhibit, a wacky museum, covered wagon rides, and celebrities who were likely to pop in. Small, warm, friendly, inexpensive, and impeccably clean Weeki Wachee had word-of-mouth support and a good marketing team.

Florida productions of the time included *Airport 77, Legend, Moonraker, Smokey and the Bandit 3, Cross Creek, I Spy,* and *Never Say Never.* Florida was the hot spot for films, music makers, writers, and artists.

Yuppies replaced hippies, and discretionary income was everywhere. The state swelled with permanent residents and "snow birds," plain folks who wintered in Florida. Water was everywhere and Floridians had more ways to exploit it than Disney had animators. There were airboats, fishing boats, canoes and kayaks, houseboats, manatee exhibits, play with the dolphins, water skiing, scuba and skin diving, amphibian planes, alligator tours, and mermaids.

ONCE A MERMAID, ALWAYS A MERMAID. The life became a sort of subculture for the participants: it was a part of their lives that conjured up memories of great times, excitement, and a sense of a job well done. Here are Ed (left) and Mary Darlington (now Fletcher) in a nostalgic pose at a reunion show. They both say performing is still fun, but somehow, that 74-degree spring water feels colder every single year.

DOLPHIN POWER, WITH AN ASSIST FROM HORSEPOWER AND WOMAN POWER. This was a fantastic addition to the props and sets of the theater of the fantastic. This dolphin performed countless times, spewing silvery bubbles, propelling pretty mermaids across the "stage," and delighting children for years.

MERMAIDING ISN'T GENETIC, BUT. . . . Tasula "Sue" Georgiadis Murray (left) is as captivating as her mom, Bonnie Staley Georgiadis (right). Sue, a 19-year-old rookie, followed in Mom's . . . tail twitches? Bonnie was an integral part of Weeki Wachee's mystique for 37 years until she retired. Hired as a mermaid, she served at various times as supervisor, choreographer, set director, designer, costumer, writer, photographer, and animal specialist. This extremely talented woman enjoyed every minute of it and made a lasting impression on hundreds, if not thousands, of people (and lots of mermaids, as well). Bonnie generously provided much of the background information and mermaid identification for this book. She carries an enormous amount of history in her head about Florida, the park, and the wildlife here. If anyone personifies Weeki's heyday, it might be Bonnie and her friend Genie Young, but they would modestly point to all their co-swimmers.

UNCLE SAM WANTS YOU. He at least wants your money, as this annual reminder showed. The audience was treated to public service announcements, the likes of which they had never imagined. It was all in the spirit of good fun and always got a laugh. The mermaids can actually hear audience response, and laughter is wonderful feedback.

ANOTHER HISTORIC FIRST, 1960. This is a vintage picture postcard. The mermaid is Vicki Vergara Smith. She still swims each month with the Former Mermaids. This photograph, though it doesn't capture a very elaborate costume, was taken from the first costumed and choreographed show-oriented production. Prior to this, the mermaids demonstrated activities underwater. From this point, music was played to the audience as mermaids "acted" in musical shows.

BIRDS OF PREY AND BIRDS OF COLOR. It was wonderful to watch the bird shows at Weeki Wachee. As you walked through the park, the calls and squawks of the dozens of birds gave the feeling of a South Sea island. Fourth from left in the bottom row is Dana Proeger with a great horned owl. The middle bird on the first row is a caracara.

THE SWOOPING BIRDS OF PREY. Trainer Susan and a crowd are mesmerized by what's happening off camera. No doubt it has to do with natural bird behaviors, coached by the handlers. Audience members had a chance to participate in the various performances. Even if you had to stand in line for half an hour to get into the arena, it was well worth the time.

81

It's a Bird. It's a Plane. No, It's a Bird. Visitors with ornithophobia, or fear of birds, would never have made it through this thrilling exhibit. It was staged in a large area with a permanent grandstand with several hundred seats. As the show began, one animal trainer stood at the bottom right corner of the grandstand (pictured) and one at the top left. At a signal from the handler standing out in the arena field, one of the majestic trained birds of prey was released by the handler on the top step and would swoop down over the crowd, sounding its call. The audience watched in amazement and could hear the swish of wings as the bird made its way to the handler below and settled on her hand.

YOU CAN'T JUST THROW ON A PAIR OF COMFY JEANS IN THIS WATERY WORLD. Getting dressed is more complicated for a mermaid, even if she has the advantage of not actually having to do it underwater. This mermaid, maybe Marilyn Reed Allen, shows how interesting the process can be. It had to be done multiple times a day, seven days a week, all year-round.

A GIRL JUST CAN'T GET ANY PRIVACY. Mermaid Marilyn Allen demonstrates donning her tail. The costumes were skin tight, of course. Those who have ever flopped down on a bed to wriggle into a pair of pants that shrank a bit can empathize with her plight. An attack of the giggles makes it that much tougher.

CALM AND COLLECTED, MARILYN TAKES A QUIET MOMENT. This pose is completely reminiscent of many paintings of mermaids through the ages: a serene expression on a beautiful sea woman and nature's bounty spread before her. It must be grand to work in a job that fills the senses with natural wonders at every turn, even if it is hard work.

TRADITIONS, AS IN ANY SORORITY, 1986. It would surprise no one to learn that this exclusive sisterhood developed its own traditions and ceremonies. These girls were proud of their occupation and felt they were all family. It makes sense that a Christmas card would develop over the years. This one is from Genie Young and the ladies she swam with.

WOMAN'S WORK SEEMS NEVER TO BE DONE, AND ISN'T THAT MUCH FUN. Though this bathing beauty seems quite content, it is unlikely many people would want to take her place. This young woman is Stacey Lin. Why she has that fellow around her or what the situation was is lost in the lore of the City of Mermaids. It goes to show, though, you never know what you'll encounter there.

TAILS CAME IN ALL SHAPES, SIZES, AND COLORS. Costume design was important in conveying the essence of a particular show or program's theme. This is Barbara Wynns, a mermaid who has been invaluable to Weeki Wachee since the 1970s. Her costume is elegant, basic black, and appealing. Barbara, with mermaid helpers, maintains and preserves the organization's photograph archives dating back to the 1930s.

85

GOOD GROOMING IS, OF COURSE, ESSENTIAL. A girl can never be too particular about her appearance. This is Barbara Wynns demonstrating a classic mermaid pose, known long ago as "the mermaid in her vanity." Depictions of this pose were not uncommon on crests in ancient heraldry, when every family had an illustration to symbolize their heritage.

GRACE, ELEGANCE, AND DEDICATION: THAT'S WHAT MERMAIDS ARE MADE OF. Shown is a typical mermaid pose frozen in time forever. Mermaid Barbara is executing a very controlled swoop from the top of the spring to the bottom. The choreography is specific, well planned, and continuously rehearsed to make sure the presentation is exactly right.

A NEW GENERATION OF NEPTUNE'S DAUGHTERS. Weeki Wachee didn't train mermaids quite as young as this; they had to be 18 years old. Mermaid Barbara Wynns and the little daughter of high diver Scott were certainly the envy of young park visitors as this photograph was taken. This young lady would now be in her 20s and could well be the mom of future mermaids at this point.

MERMAIDS GO WITH BUBBLES LIKE FAIRIES GO WITH WINGS. In every generation of mermaids, photographs with Bubbles, the park mascot, are a tradition. This shot is from days gone by, but today, you might see little girl mermaids posing there in Mermaid Camp. Weeki Wachee today invites little girls to sign up for a mermaid makeover, daily water performance lessons, and a chance to be in the mermaid show.

87

GOT MILK? 1976. The 1970s were an era of growth and change in Florida as everywhere else. Spring Hill, the community surrounding Weeki Wachee, was a favorite target location of tract home builders. In 1976, as a group of builders cleared land for new homes, they caused a huge amount of clay and sandy soil to drift down-river and end up in the spring. The spring water, usually clear as glass, turned as opaque as milk over night. You can't have a mermaid show if no one can see the maids, so for about nine months, until the water returned to normal, the park presented high-dive exhibitions by national and world champions. The mermaids did routines on shore but some wondered if they'd ever be able to use the theater again. This diver is Don Columbo or Al Valedaris. Bonnie Georgiadis used a Yashica to shoot this.

GENTLE CREATURES ENJOYING THE COMPANY OF CURIOUS HUMANS. As the train traveled around the park through lushly forested areas, riders often had close encounters with a variety of nature's creatures. Some were quite tame, some perhaps were not. Audiences were always admonished to keep hands, legs, and heads inside the ride and to be aware that animals' behavior is unpredictable.

OVER THE BRIDGE AND INTO ANOTHER WORLD, c. 1980. Go through an elaborate turnstile gate, across a bit of lawn, and then cross a picturesque wooden plank bridge over a rippling brook. Now you're in a world of exotic creatures. Ahead and left is the bird show, to the right lies Mermaid Theater, and far down the path are the river cruise boats.

ALL CREATURES GREAT AND SMALL—PART OF THE PARK'S PERSONALITY. This is Ozzie; his wife is Harriet. Incredibly beautiful birds of prey were cared for, housed, and trained in the park. There was, and still is, a covered outdoor grandstand where people gathered to sit in the shade and watch demonstrations of different bird behaviors. One handler would stand in the top row of the pavilion and release a majestic bird like this to soar over the crowd and land on another trainer's gloved arm. You might be awed by the graceful swoop of a hawk, the flight of an owl, an eagle, or any number of birds. At one time, various private owners of the park sold off the birds and the show was discontinued, but now, it is being redeveloped as new birds are acquired. Another generation of children can see something they might encounter nowhere else.

HIS NAME IS FORGOTTEN, BUT HIS LEGACY LINGERS. Sadly no one could recall this fellow's name, but certainly, his impact on the area is not forgotten. There are still owls in the woods around the river, and many are his (or her) descendants, no doubt. It is said that today's children have limited opportunities to experience wildlife in natural habitats; this is certainly a terrific reason for venues like Weeki Wachee to survive, grow, and prosper. If children sit quietly on the boats and in some areas of the park, they'll see animals aplenty.

A GIRL, A HORSE, AND A DESCENDANT OF THE DINOSAURS. Here's one of the bird ladies, Shelly Williams, with a red-tailed hawk. She, Dana, and Mavis were skilled experts in handling animals and in entertaining children and adults. This scene is right out of one of the bird of prey shows. Imagine how thrilling it looked on a balmy Florida afternoon.

THE LEGEND OF PRINCESS WONDROUS. Nestled quietly and permanently in the park, among flowers, birds, and pastoral beauty, is a permanent plaque explaining the mermaids' most prized legend. Here is the story of how Neptune's daughter, Princess Wondrous, came to reign at Weeki Wachee, written by Jack Clem, a friend of the park and the mermaids.

HANGING AROUND IN SUNSHINE. The river cruise was highlighted by stops along the banks of the Weeki Wachee. Passengers saw raccoon families, exotic birds like flamingoes, some monkeys, and the obligatory alligators. This is a good shot of one of the raccoon residents of the shoreline. They were used to seeing the boat come to shore and knowing the captain would likely have a fish treat for them.

KING NEPTUNE AND HIS COURT, 1980s. Neptune, the ancient god and king of the sea, is known as the father of all mermaids, so of course, he is prominently featured in the park. Here, the king holds court with four of his loveliest subjects and one that's kind of iffy. Most of the settings and decorations at Weeki Wachee were designed with assistance from park staff and made locally by a company in St. Petersburg.

MERMAIDS, MANATEES, AND NATURAL WONDERS. Terry Ryan clearly demonstrates the lovely look of long hair drifting in water. Her makeup is exaggerated to enhance her face as seen at a watery distance. The springs of Northern Florida, according to *National Geographic* in March 1999, are "profoundly mysterious. The rivers they feed arise for no apparent reason . . . and vanish just as curiously." Perhaps that's why the mermaid theme fits so well.

GOING DOWN THE TUBE, BUT ONLY IN THE BEST WAY. For a long time in the early days, the mermaids entered the spring by diving off the far bank. This was inconvenient for a number of reasons: it diluted the mystery, it couldn't easily be done in tails, weather could be a concern, and it was time consuming. At some point, probably in the 1970s or 1980s, a new entry method was unveiled to the delight of the swimmers. In the dressing rooms above the theater, maintenance staff installed a large tube about four or five feet across with a ladder against its inner wall. It led to the main spring near the theater viewing window. This is a fantastic shot of one unidentified mermaid in mid-jump and two others waiting their turn to enter the water for the next show. On the left is Mermaid Dianne McKee; on the right is Beth Thomas.

BUILDING THE FANTASY. It was sometimes hard to tell where fantasy began and reality left off, especially once huge sets were lowered into the water and settled dozens of feet below the surface. This work of art, worthy of any Hollywood back lot, could be for *Mr. Peabody and the Mermaid*. Often, local people did the work and some of the design.

WHERE THERE'S FILM, THERE MUST BE SOUND. The challenges for sound engineers were enormous: how do they film above and below water, getting only the sounds they want and none of the background commotion? They managed through trial and error to find just the right levels. It may have helped that the sound at this time was recorded in monaural, not in stereo or Dolby.

A SOURCE OF WEEKI WACHEE LORE AND HISTORY. Jill Roddis makes fudge in the candy department. She has been a loyal fan and an employee of the company for many years. Jill remembers when an alligator came up the path and into the store; the manager said, "I handle a lot, but I am not handling this!" She calls the crew her family; people seldom leave once they're hired. She notes three generations of the Flowers family working with her: Judy White, her daughter Nancy Flowers, and Nancy's daughter Heather Flowers, who does mermaid promotions. Jill's son has such fond memories of his childhood, playing around mermaids, that he suits up now and plays Santa in the park every Christmas.

SUGAR AND SPICE AND GLAMOROUS WOMEN, c. 1970. This is Diane Fry in a publicity photograph advertising lollipops sold in the gift and snack concessions. Diane's modified Nehru collar and broad vertical stripes are the epitome of the era's fashion. Her smile and bright eyes are everything one could expect from a mermaid. There was a war in Vietnam, but this magical life was an escape of sorts.

WHITE-THROATED TOUCAN AT SNACK TIME, 1980s. Once upon a time, the park was filled with animals. There were birds, of course, and land animals and sea animals common and exotic. Old-timers remember how attached staff members were to park creatures. One day, for example, Geraldine the monkey jumped off the tour boat and, scared, climbed a tree. The captain plied her with pecan rolls to coax her down.

MERMAID REUNION 1983: THE WHOLE CREW. Pictured from left to right are as follows: (first row) Lou Spike's daughter Sandi, unidentified, Genie Young, and two unidentified people; (second row) Peggy Campbell wearing glasses, Newt Perry, Angie Molzer, Melodie or Melinda Harding, and two unidentified people; (third row) unidentified girl waving, Debbie Poore, unidentified dark-haired woman, unidentified woman sitting low, Jenny Farnsworth looking off-camera, and Susie Spencer looking down; (fourth row) Linda Seeley with jacket, Tammy Mathey, Vera Huckaby, Trudy Jennings, Carol Parish, Helene Benson looking down, Nancy Hunnicutt, and unidentified; (fifth row) three unidentified people, Kim Cox, unidentified, Holly and Dolly Harris, Kim van de Bus, Sharon Cyack, four unidentified girls, Bonnie Staley Georgiadis, Barbara Bates Jones, and unidentified; (back rows) Jana Cofer in diagonal strips, Ed Darlington in second to last row, Barbara Reed to his front right, and Suzanne Palecki behind him. The rest are unidentified.

THE HOUSE WAS ALWAYS PACKED. These days the crowds are somewhat smaller, perhaps a function of how sophisticated entertainment and our tastes have become, but in its day, this little theater was packed to capacity for every show, rain or shine. There were shows almost hourly throughout the entire week.

OPPORTUNITY FOR AUDIENCE PARTICIPATION AND A LOVE FOR ALL CREATURES. Here is a clear demonstration of this gentleman's good sportsmanship and his devotion to fine feathered friends. The bird is a green macaw, the woman is one of Weeki Wachee's bird handlers, and the gentleman was sitting in the audience just a moment before this shot was snapped.

GOD BLESS AMERICA AND MAY SHE HAVE ANOTHER 200 YEARS. The year was, of course, 1976, America's bicentennial, and everyone was celebrating. The mermaids were no exception and decided to do it up big. It was an incredible sight when this lovely young lady rose up from beneath the bowl of the spring with these patriotic symbols waving. Keep in mind that this was done underneath a whole lot of water. It isn't easy to get flags to unfurl, let alone to wave symmetrically. Every single action in these performances had to be planned, rigged, and carefully staged so that it worked right the first time. There were no second chances.

MERMAIDS STARRED IN CLEVER CARTOON. They are irresistible, those daughters of the deep. A local artist pen-named "Unda Water" did a series of cute cartoons in honor of the ladies. It is unclear if these were ever published or just done for the fun of it, but they generated delighted giggles among the daughters of Neptune. The identity of the mermaid in the cartoon is unknown.

BACKSTAGE AT THE MERMAID THEATER. This is a rare image of behind-the-scenes preparations for a show. The ethereal and eye-appealing results look so perfect it's hard to keep in mind that these women put hours of preparations, practice, dressing time, and workouts into their careers. As with any worthwhile endeavor, the preparation created a strong foundation to support those excellent performances. This image is c. 1965, and the mermaids are unidentified.

STAR TREATMENT? NOT UNLESS YOU'RE CHARLIE TUNA. Note how very young these performers are. Many were seniors in high school in the early days of underwater shows. Later management required them to be 18 years old. Not seasoned veterans, these kids had a hard job cut out for them, but they loved it. They did their own make-up, and many of them did their own costumes; programs were written in house, too.

EVOLUTION OF AN UNDERWATER THEATER. Across 60 years, what was a simple 15-minute roadside demonstration evolved into a unique theatrical world. Once upon a time, half a dozen mermaids came to work in swimsuits, dove into a cold spring, and amazed a handful of onlookers. Later, a dozen or two young ladies in sequined tails danced among elaborate sets and had a well-equipped dressing room where they prepared their magic.

TEACHERS, TRAINERS, AND COACHES, OH MY! Becoming "good enough" to entertain under water didn't happen overnight and didn't come as a born talent. Every girl was thoroughly trained for months. These students are, from left to right, Marilyn Reed Allen, Bonnie Georgiadis, and Vicki Sharp, taught by Lauretta Jefferson (kneeling). Classes like this kept the girls in athletic condition so they were capable of demanding physical challenges in shows.

IN THE EYE OF THE BEHOLDER? Merpeople stick together, even when the task is escorting an unusual bathing beauty. The lovely sisters don't mind a bit; it is all in the family. From left to right are unidentified, Genie Young, unidentified, "Ed the Great" Darlington, and Bonnie Georgiadis. A road in Holiday, Florida, is named after the Darlingtons. Bonnie is from Tarpon Springs, and Genie lives near Weeki Wachee.

103

BEACHED MERMAIDS, 1970s. Try to imagine moving 13 mermaids with tails around acres of park territory to do photo shoots, autographs, and shows. Most theme parks don't have these problems. From top to bottom, they are four unidentified, Vera Benson Huckaby, Terri Hamlet, three unidentified, probably Cheryl Wood, unidentified, Karen Sykes, and unidentified.

THIS POSE MAY HAVE TAKEN SEASICKNESS TO A NEW PLATEAU. The Ferris wheel pose was tough to master, and once the girls got in position, rotating the pose was even tougher. They'd form the wheel, hold on to each other, and revolve just like a Ferris wheel. The wheelers are not identified here, but this was early, judging by the lack of tails.

Four

The 1990s and Beyond

The mermaids' home, while threatened from time to time with various problems, looked like it was on the way to recovery and prosperity. The park was donated to the City of Weeki Wachee by the last commercial owners, and under the guidance of Mayor Robyn Anderson and public relations guru John Athanason, the staff and fans rallied around a media blitz campaign called "Save Our Tails."

Beautiful old decorations like a ceramic tile mural and unique statues were restored. Grounds were re-landscaped, the bird show found its way back to the park, and potential mermaids still clamored for a place in the underwater world.

Former mermaids decided to produce and perform their own shows in addition to the entertainments created by the new crop of mermaids. The public loved it.

Though the land encompassing the home of the mermaids is government owned, Weeki Wachee seems to be proving itself a desirable tenant who cares for the ecology and protects the animals. Old Florida is pretty much gone now. There are one or two independent exhibitors who find a way to keep their roadside attractions hanging on, but most of the parks, zoos, and attractions closed long ago or have been purchased by large companies and modernized.

Weeki Wachee, the smallest city we know of, the City of Mermaids, is a reminder of simpler times, quieter pursuits, and the magic of myth. May it grow and prosper.

MERMAID MARJORIE NAVE TRYING HER TAIL, 2005. The chore is almost as intricate as trying on a wedding dress. The tails have to fit perfectly and be skin tight so as not to hamper movement. The leg (or fin part) has to be roomy enough to accommodate dive flippers worn inside, but it cannot be baggy. This is no easy task, but somehow, with multiple fittings, it all gets done by curtain time.

LANDMARK KNOWN TO GENERATIONS OF HIGHWAY TRAVELERS. The park's perimeter is lined with sculptures of mermaids. This one depicts the adagio pose, a symbol of the organization. Time has taken a toll on some of the statues, but renovations underway now will put things back right. The concrete mermaids designed by St. Petersburg sculptor Gene Eley and concrete fabricator Ed Lach were the brainchildren of Miami architect Robert Collins.

MARKING 50 YEARS OF MAGIC WITH A HUGE REUNION, 1997. This was an incredible project to organize, and it took months. Former mermaids and Weeki Wachee management got together and attempted to compile a list of everyone who had ever worked there. They put together a very large list and are still adding to the database. There is no way to even try to identify all these folks, but each of them made their mark upon the 50 years of excitement and hard work. More than 100 people celebrated this reunion. In 2007, the park's 60th anniversary, the mermaids hope to hold an even larger party and find more participants. They're working now on searching out anyone who should be invited. The organization's Web site, http://www.weekiwachee.com, has a bulletin board where former employees and significant others can log in to be recognized and added to the list. Shows of the time included *Alice in Wonderland, Wizard of Oz, Cinderella, Little Mermaid, Peter Pan,* and a magic show

RESTORATION OF A GEM. After hard times and a change of ownership, the staff committed themselves to restoring the park. Dubbed "Save Our Tails," the message was carried to national and local media and across the sea to Europe. Here a crew of volunteers from a chain of retail home centers rebuilds the entrance bridge. Month by month, visible progress is made.

AN EXCELLENT REASON TO SAVE THIS PLACE. This is a snowy egret, a shore bird that loves the springs. Every year there are fewer habitats. This shot was taken from a kayak drifting downriver. This fellow stood on a platform for perching and feeding. The photographer came within three feet before the bird rose like a kite and soared overhead, his feet nearly ruffling the photographer's hair.

THE EMBLEM OF AN ENCHANTED PLACE. This is the logo used by Weeki Wachee. The official colors are sky blue and white. At one point in the 1990s, it began to seem as though the park would close, as many roadside attractions have around the state. Now the future looks brighter. Mermaid camp, diving events, the water park at Buccaneer Bay, and special events throughout the year have pulled the mermaids out of the doldrums and put them back on the map.

MEET HER HONOR THE MAYOR OF WEEKI WACHEE. Robyn Anderson is a former mermaid, general manager of the park, and mayor of the tiny city of Weeki Wachee. In the late 1990s, the park's former owners donated the park to the city. With lots of ups and downs and multitudes of challenges, the mayor and the residents have come a long way with restoration.

SEA DIVER PROJECT—A NEW CONCEPT FOR WEEKI VISITORS. Mark Warren and Chris d'Felis created a mermaid's-eye view of the spring basin. For a fee, participants learn basic scuba and tour from the water's surface while breathing through a regulator. Chris d'Felis is standing at left. Others are, from left to right, (first row) Kim Romanowski, Virginia Connolly, Jennifer Griefenberger, and Desiree Collier; (second row) Dennis Docette, Jason Pond, Tim Bruin, Mike McHugh, and Mark Warren.

THE MERMAID CREW IN APRIL 2005. From left to right are Heather Flowers, Angela Schommer, Denise McGrath, Sara ?, Heather Miller, Erin Eppley (granddaughter of former mermaid Bunny Eppley), Amy Purnell, Carli Dofka, Abby Anderson, and Jamie Stockton. These are the modern mermaids. Being a mermaid is only temporary. Some past Neptune's daughters have traded tails for careers in airlines, law, medicine, accountancy, motherhood, pulmonary therapy, real estate, and business.

BILLIONS AND BILLIONS OF BUBBLES. Between scenes, between acts, and before and after each performance, instead of drawing a curtain, stagehands create a wall of bubbles. Compressed air is forced up through perforated pipes below the theater viewing window, and the effect is marvelous. There are places throughout the staging area that can produce gobs of bubbles, too.

MODERN MERMAIDS AREN'T MUCH DIFFERENT. Nowadays they don't live on the property, since much of the land has been sold and the cabins, cottages, and thatched huts are long gone. But the rules are still strict, and the training even more rigorous than in days gone by. The safety record is still intact.

MUST BE SEEN TO BE BELIEVED, 2004 NEWS REPORT. *National Geographic* news reported the following after visiting mermaid land: "At a west Florida intersection, where the 21st century runs headlong into 1947, is a roadside attraction that must be seen to be believed . . . no Disney characters or underwater mannequins, but living, breathing, bubble-blowing mermaids an hour north of Tampa."

Learned Behaviors Entertain the Crowds and the Birds. Animal experts explain that if the training is done humanely and lovingly, animals have as much fun demonstrating behaviors as people have watching them perform. Families who visited the exotic bird area of Weeki Wachee saw unstressed, perky, playful little guys doing clever things for fun and treats.

Fitness is not just for Humans. As early as the 1980s, trained birds like Duster the crested cockatoo, pictured here, figured out that to keep in shape, exercise was a must. It is pretty amazing to watch a bird ride a bicycle across a tight rope. This cockatoo was a star and seemingly never tired of showing off.

MANATEES, 2005. Not actually a Florida species, West Indian manatees are huge, gray mammals. Their clumsy bodies narrow to a flat, paddle-like tail. The average manatee weighs half a ton. In summer, these fellows swim as far north as the Carolinas, moving slowly and spending most of the day grazing for food on the bottom of shallow waters. This photograph was taken by Leon Behar.

THE LITTLEST MERMAID AND THE TAMPA BAY BUCCANEER CHEERLEADERS. Visitors can't resist mermaids, and when the mermaid is this adorable, she's a show-stopper. This toddler is Brooke, the daughter of Weeki Wachee's mayor, Robyn Anderson. In about 17 years, she may be the star of an underwater extravaganza.

A MERMAID IS FOREVER. Her charm does not fade. This is Mary Darlington Fletcher (left), the first mermaid; her brother Ed, the first merman; and mermaid Tania Olson Sanborn (right). This picture is from the 1980s. The Darlingtons have a lasting love for the underwater theater and still attend reunions and share the park's history with those who are interested. They began their subterranean secret life in 1947.

MERMAID DOTTIE, A STAR FOR NEARLY 60 YEARS, c. 1950. Here is Dottie Kulic Meares, one of the brightest stars in the mermaid city. She began her career around 1950 and is still swimming at age 71. Dottie's grace and strength have not diminished. She says, "When I'm in that water, I'm 19 years old." She is quite used to demonstrating techniques like feeding the fish and is a joy to watch.

DOTTIE KULIC MEARES, ENTERTAINING AUDIENCES FOR HALF A CENTURY. This is Dottie in 2004. She now performs with the Former Mermaid group about once a month. Keep in mind that the water temperature in the spring is 20 degrees colder than the human body's temperature. Dottie and the other Former Mermaids do a 30-minute show, and their body temperature drops one degree every 15 minutes, according to the introduction information in the theater. Dottie swims like a fish—or rather, like a mermaid. She swims right-side up, upside down, backwards, and forwards. Her sparkling personality is evident as she tells the audience before the show, "I believe you don't stop playing because you grow old, you grow old because you stop playing." She says she'll never stop.

THE TRADITIONAL BUT MODERN MERMAID WAVE. This is mermaid Carli Dofka, pictured in a summer show. At the end of nearly every underwater show presented at Weeki Wachee, the mermaids swim toward the huge expanse of glass in front of the audience, wave, and bow, bestowing smiles of genuine appreciation on their fans. Young Carli is immortalized demonstrating that traditional sign-off.

GOD BLESS AMERICA. Like many Americans, the swimming performers have strong feelings of patriotism and never tire of celebrating America in their work. This show honored the flag and American troops for Columbus Day. It was a spectacular crowd pleaser. At one time, the mermaids did up to eight shows a day. The pace is slower now, but the enthusiasm hasn't waned a bit.

A MOST APPEALING MERPERSON, c. 2000. Undersea stars like Ed Darlington, Weeki's favorite first merman, met people from all over the world: from Europe, Asia, Arabia, and Africa. None of the visitors went home saying they saw nothing out of the ordinary, especially with Ed's comedic talent and lack of inhibitions. Weeki Wachee workers always said, "If you felt a bit down, just going to work would perk you right up again."

THE 21ST CENTURY BRINGS TELEVISION AND MOVIE CREWS BACK TO THE SPRINGS. Glen Pla of *The Average Angler* visited to explore the possibilities of the river and the spring. The show is a popular fishing spot on cable television. Pla, who used to teach movie making to college students, knows a good location when he finds one. He interviewed mermaid Amy Purnell, right at home on camera.

WATER LADIES AND A GENTLEMAN, 2001. Pictured from left to right are the following: (first row, reclined) Ed Darlington; (second row) Marianne Bennet, Dottie Kulic Meares, Billie Fuller, and Susanne Pennoyer; (third row) Pat Crawford, Becky Young, Lynn Columbo, Bev Sutton, Krista Robson, Dawn Douglas, Barbara Wynns, and Mary Darlington Fletcher. These are the people who began and perpetuated the legend. Recently Weeki Wachee has become a very popular subject for England's reality television shows, spurring an influx of foreign visitors.

NOT VERY ROMANTIC, BUT COMPLETELY CHARMING. This is mermaid Amy Purnell, c. 2004, kissing one of the mystical creatures of the deep, the Florida manatee. These docile creatures are vegetarians. They live in the Gulf of Mexico in summer, but they winter upriver in Florida's springs for the warmer water. Manatees are amazing animals often seen in the waterways. They are at risk of great harm from boat motors.

THE LITTLE MERMAID PERFORMED BY THE *REAL* MERMAIDS OF WEEKI WACHEE. In the early 1990s, not long after the Disney Company's 28th animated feature film swept the country's movie box offices, the mermaid players produced their version of the famous Hans Christian Anderson fairy tale. The cast, pictured here, consisted of six girls and two young men in full uniforms and tails.

THE MORE THINGS CHANGE, THE MORE THEY STAY THE SAME. Visitors can of course see differences in the park, the mermaids, their swimsuits, and their shows. But the feeling of magic and mystery, the delight of watching graceful movements underwater, and the fun of seeing a unique theater presentation will be a constant in Spring Hill, Florida. This is Abi Bell taking a breather, so to speak, at the bottom of the spring.

THE RETURN OF THE BIRD SHOWS. Year-round, visitors are happy to see the bird shows reestablished. The charming and popular exhibit always features smart little critters like this colorful macaw, who is about to say a few words to the crowd and show them his tricks. His handler's name is Julie Rivers, but the bird's name is not known.

EVERYTHING OLD IS NEW AGAIN. That includes the new underwater sport known as Snuba, a patented process allowing more freedom than snorkeling but less than scuba diving. Divers attach a 20-foot air hose to a dive tank and leave the tank on a raft. The mermaids would find this very familiar, judging by the amount of time they have collectively spent doing hose-breathing.

YESTERDAY TO TODAY. Mermaid Abi Bell, who was kind enough to provide images from her personal collection, is part of the new age of performers. You've now seen 60 years of development, planning, and hard work, and hundreds of workers making a go of it. Millions of spectators gaze in wonder, year after year, at a daydream starring Neptune's daughters.

AND THIS IS BACK TO HOW IT ALL BEGAN. Weeki Wachee began as an adventurous man's "what if"—a gaggle of high school girls showing casual passersby what interesting things could be done underwater. A round of applause and many thanks are due to Newton Perry and all the ladies of the Weeki Wachee Springs, including his daughter DeLee. May it all continue for a long, memorable time. This is Elsie Jean Wernicke Bell, trainer/mermaid.

A Treasure for the Ages. Land in Florida is becoming scarce, as more than 250 people a day relocate to this state. Land is earmarked for new homes, and that means building more schools, hospitals, and churches. This gorgeous piece of wetlands encompassing one of the prettiest rivers in the world is a place that should be secured as it is for generations to come. The mermaid legend spans thousands of years and every culture. Florida mermaids are unique in the world; there is nowhere else to experience this delightful entertainment. Through good times and bad, this park has managed to survive. If you include the City of Mermaids in your vacation plans at some point, you won't be disappointed.

A FINAL WORD ABOUT THE MANATEES. Manatees and mermaids are closely tied in folklore and reality. These gentle animals are part of the ocean ecology. If they become extinct, something important will change, and that change will cause other changes in the ecosystem. There is no way to predict what the alterations will bring about in Earth's seas. Even looking past conservation issues, manatees are incredible to watch and fun to interact with. They are vulnerable to injury by boats and fishing equipment because they move slowly and cannot get out of the way. Every year, many die from injuries inflicted by people enjoying Florida waterways. If you travel to America's ocean paradises, please keep a watchful eye out for manatees, dolphins, and the other wondrous creatures that inhabit the deep.

List of Mermaids

Ruth Adams
Claudia Tatum Age
Shinko Akasofu
Carol Allison
Susan Myers Bacaline
Jacqueline Backas
Jennifer Banfield
Martha McKinnon Barnes
Mary Kyle Bartholomew
Georgia Beadle
Stacy Beaulieu
Abi Bell
Jessica Bell
Marianne Mirt Hope Bennet
Beth Bartholomew Bilodeau
Amy Blevens
Alicia Cuomo Peterson
Blodgett
Judy Bond
Debbie Bortinelli
Susanne Pilecki Boyd
Patsy Boyett
Bud Boyett
Jan Brand
Eileen Brennan
Kathy Lloyd Brennen
Sherry Martin Bresnahan
Pat Brett
Penny Briggs
Arlene Mahoney Brooks
Dan Brotscul
Ricou Browning
Dena Wills Burgess
Donna Burich
Veronica Dunn Califf
Lee Caltagirone

Lissette Caminero
Jean Capets
Deborah Carlin
Raquel Carter
Hattie Carver
Peggy Cavanaugh
Rhonda Hope Chancey
Kathleen Chichester
Patty Euler Chipley
April Chircop
Judy Cholomitis
Barbara Chorvat
Yvonne Chorvat
Kathleen Christianson
Barbara Clark
Mary Sue Wernicke Clay
Dixie Clayton
Sandra Clements
Pat Cleveland
Annette Cline
Jana Chytka Cofer
Velma Jordan Coker
Angie Anderson Coleman
Bonita Colson
Lynn Sacuto Columbo
Debbie Comstock
Anna Stefan Cooke
Linda Cooper
Donna Rukenbrod Cowden
Shirley Cowden
Kim Cox
Kimberly Coyne
Patricia Craft
Patricia Cleveland Crawford
Amy Crotty
Barbara Reed Cunningham

Terry Cusmano
Karin Daily
Ed Darlington
Veronica Dunn Derm
Cathy de Vore
Barbara Reed Dixon
Melissa Dodd
Lydia Ann Lovarcik Dodson
Trudy Bannow Dodson
Jennifer van de Vusse Dola
Mike Dono
Gerry Hatcher Dougherty
Dawn Lute Douglas
Wahnita DeFrancesco Dow
Matt Driskell
Eric Ducharme
Linda Hall Duda
Nibsic Towne Duffin
Holly Dugan
Doreen Kurz Durandetto
Kare Dutcher
Sharon Cihak Elliot
Judy Ellis
Erin Eppley
Lana Taylor Erickson
Angela Mulzer Erwin
Jen Eulo
Dee Farmer
Susan Cain Farmer
Jenny Farnsworth
Julie Faucher
Lou Spikes Ferreira
Mike Fields
Kay H. Finney
Tina Fischer
Mary Darlington Fletcher

125

Melinda Flinn
Cherie Flowers
Kathy Flynn
Amy Fobell
Mimi Foster
JoAnn Fell Frazier
Diane Fry
Richard Fujimoto
Billie Monk Fuller
RitaAnn Garrett
Joan and Buck Gately
Bonnie Staley Georgiadis
Beth Goldsby
Edith Gonzalez
Marianne Hope Gores
Nanette Hewitt Grasso
Betty Graves
Mary Lewis Green
Ruth Johnson Greening
Patricia J. Griffen
Judy Guilliam
Barbara Brooks Guyton
Tammy Gyarmethy
Holly Hall
Julie Stepaniak Hallal
Ginger Stanley Hallowell
Melinda Harding
Kay Harkness
Terry Hamlet
Geri Hatcher
Susan Holt Hatcher
Theresa Hatcher
Helene Benson Hawkins
Lisa Hawkins
Robyn Haywood
Sarah Katie Heavens
Dolly Heltley
Marjie Hendrickson
Margaret Hewitt Henkle
Harriet Hope Hickox
Jeanette McDonald
Hollenhead
Lola Hoobler
Melody Harding Hope
Joy Gatewood Hope
Susan Sweeny Hopkins
Andrea Huber
Jeff Huber
Vera Benson Huckaby
Catherine Huckaby
Nancy Harkness Hunnicutt
Suzanne Hutchins

Cheryl Lyrclark Hutchinson
Brenda Indermuel
Emily Jarrard
? Jefferson
Trudy Jennings
Wendy Johnstone
Barbara Jones
Carl Jones
Carmen Jones
Debbie Poore Kaufman
Margie Kelly
Cheryl Cucinotta Kelly
Cathy Bates Klein
Rita Ann Koblinski
Sue Kovac
Tina Bonozek Kycynka
Martha Steen Lambert
Eileen Roush Langworthy
MaryJane Law
Sandy Lawhun
Sandy Lawson
Kimberly Pippin Lawrence
Donna Davidson Leake
Joyce Stiles LeCroy
Robyn Ledbetter
Barbara Leete
Bobbi Lehman
Charmaine Letner
Krista Lewis
Kathy Lile
Susan J. Lockwood
Vonnie Harrison Lovett
Tracie Lowman
Stacey Lin
Viki Mallory
Ruth Ann Skinner Manuel
Nicole Marino
Jinny Marmo
Vicki Sharp Martin
Kerry Mascio
Linda Mashburn
Judy Mastalerz
Tammy Mathey
Kim Budrick Mazzuco
Pamela Dell McDaniel
Dianne Wyatt McDonald
Julie Bleich McLamb
Jean Bell Ernicke McMickel
Florence McNabb
Dorothy Kulic Meares
Karen Drapp Meares
Sis Meyers

Sally Middleton
Donna Paul Milam
Jean Miller
Louise Johnson Miller
Babs Johnston Minchin
Diane Mitchell
Angie Molzer
Martie Nosti Warsham
 Monaldi
Cyndi Moss
Gwynne Mummert
Sue Georgiadis Murray
Gwynne Nave
Marjorie Nave
Penny McKinley Neil
Barbara Nelson
Nell Nichols
Sami Brown Nichols
Norma Nolan
Dona Morgan Olson
Suzanne O'Neill
Beverly Carlson Orchard
Barbara Owens
Suzanne Palecki
Suzanne Parker
DeDe Smith Parmer
Carol Christopher Parrish
Betty Patton
Veronica Patton
Dorothy McCullogh Pelham
Susie Bowman Pennoyer
DeLee Perry
Newton Perry
Alicia Peterson
Amy Peyton
Tammy Watts Piacente
Carol Pickles
Wanda Weeks Piner
Nancy Thomas Poitras
Gage Bayfield Quida
Cheri Lynn Ragland
Jeanette Purdin Ramsey
Jeanette Rawlins
Pam Fredericks Reid
Margo Rhatigan
Johanna Rice
Patricia Rightley
Betty Chambliss Roberts
Crystal Barlow Robson
Krista Robson
Jeanie Brooks Rohrbaugh
Naomi Roll

Diane Wingate Rollins
Tamar Romer
Mary Dwight Rose
Donna Ruckenbroud
Beverly Sala
Linda Salgado
Tania Olson Sanborn
Bobbie Sanchez
Susie Sanchez
Sue Saxon
Sandra Schimelfening
Beverly Whiteneck Schram
Linda Seeley
Olga Roman Sexon
Morgana Sheldon
Gail Sherouse
Peggy Campbell Shoemaker
Judi Shockley
Gail Showers
Wendy Sidell
Tricia Silvey
Joniu Slavic
Joan Smiley
Cynthia Smith
Diane Smith
Dorothy Fitzgerald Smith
Kristen Smith
Penny Smith
Sandy Smith
Sativa Smith
Teri McGill Smith
Vicky Smith
Vickie Coatta Sottile
Marla Spellenberg
Susie Spenser
Sandy Spikes
Donna Sprague
Becky Stahlhut-Haldeman Young
Anna Stefan
Margo Stefan
Barbara Bates Steffy
Diane Stetzel
Ned Stevens
Lou Stewart
Betty Stoneburner
Salley DeSpirito Stukes
John Summers
Beverly Brooks Sutton
Bunny Eppley Swanson
Bootsie Moore Sweat
Karen Sykes

Anne Tappey
Beth Thomas
Darlest Clayton Thomas
Nancy Fisher Thomas
Paula Tice
Nancy Tribble
Nibsey Towne
Georgia Underwood
Amber Carroll Vagts
Laura Valentine
Tommy Vasanovski
Anna van de Vous
Kim van de Vous
Patty Taplin Vergara
Valerie Vokae
Chuck Walls
Shirley Walls
Marilyn Reed Webb
Elsie Jean Wernicke
Peggy Westmoreland
Edith Roberts White
Miriam White
Thea Whitehead
Tracey Williams
Kay Bushway Williamson
Kathy Eckelkamp Wilson
Karen Wilson
Tammy Winchester
Barbara Karwath Wishart
Cheryl Wood
Shirley Woolery
Trish Wrightly
Barbara Wynns
Becky Young
Genie Young
Mary Zellner
Mary Ann Ziegler
Linda Sand Zucco

The 2005 Merpeople:

Amy Purnell
John Summers
Megan Ryan
Carli Dofka
Crystal Videgar
Justen Durr
Heather Flowers
Dianne McKee
Marcy Terry
Jessica Doucette
Abby Anderson
Denise McGrath
Virginia Connelly
Stayce McConnell
Angela Schommer

ACROSS AMERICA, PEOPLE ARE DISCOVERING SOMETHING WONDERFUL. THEIR HERITAGE.

Arcadia Publishing is the leading local history publisher in the United States. With more than 3,000 titles in print and hundreds of new titles released every year, Arcadia has extensive specialized experience chronicling the history of communities and celebrating America's hidden stories, bringing to life the people, places, and events from the past. To discover the history of other communities across the nation, please visit:

www.arcadiapublishing.com

Customized search tools allow you to find regional history books about the town where you grew up, the cities where your friends and family live, the town where your parents met, or even that retirement spot you've been dreaming about.